LOOK UP
GLASGOW

LOOK UP GLASGOW

World class architectural heritage
that's hidden in plain sight

ADRIAN SEARLE
& DAVID BARBOUR

**FREIGHT
BOOKS**

First published October 2013

Freight Books
49–53 Virginia Street
Glasgow, G1 1TS
www.freightbooks.co.uk

ISBN 978-1-908754-21-9
eISBN 978-1-908754-35-6

Typeset by Freight in Adobe Caslon Pro and Tungsten
Printed and bound by PB Print UK in the Czech Republic

the publisher acknowledges investment from
Creative Scotland toward the publication of this book

CONTENTS

FOREWORD

I first moved to Glasgow in 1996, to work on, amongst other things, the Glasgow International Festival of Design, a precursor to the city's Year of Design and Architecture held in 1999. I remember now with embarrassment my reaction to getting the job. There was a degree of disappointment that it was, well, you know, Glasgow…

I was born in the North East of Scotland to a family who, on both sides, were East Coasters. Our gaze naturally turned east, into the wind, towards the North Sea. I spent 10 years as a child and adolescent near Falkirk and visited Edinburgh many times. It seems incredible to me now that over the course of that decade I visited Glasgow only once, to take part in a school drawing contest hosted at Kelvingrove Museum. After all, the train journey took less than 30 minutes.

I studied in Edinburgh, then worked in Yorkshire, Belfast and back in Edinburgh, reaching my late 20s with no knowledge of the city that was Glasgow other than that handed down by popular culture and prejudice. Glasgow was dirty. Glasgow was ugly. Glasgow was scary.

So walking through the city centre streets in the mid-1990s was a revelation. As my fellow commuters hurried to work, heads down, I walked with my eyes raised. I was astounded at how beautiful, how lavish the architecture was.

Edinburgh is a stunning city. Its compact nature, its buildings representative of almost every era since the late middle ages; its grand bridges, its parks, its monuments, the hills, the sea… all combine into a unforgettable experience for visitors. But the dominance of Scots Vernacular and Georgian styles gives Edinburgh an elegant restraint, wholly appropriate to the personality of the city and its inhabitants.

Glasgow couldn't be more different. The exuberance of its Victorian architecture is brash, confident, demonstrative, equal to the city's collective personality. The 19th century's equivalent of skyscrapers give the city centre a fabulously vertiginous tilt. But, for me, most remarkable is the extraordinary abundance of sculpture and architectural decoration everywhere I look. Less so the proliferation of monuments and plinths in George Square and Kelvingrove Park; more the classical figures jostling with mythical colossi and biblical heroes together with reliefs and portraits of the great and good that make Glasgow unlike any other city in the world. It was surprising, alarming but also somehow reassuring when I first realised just how many pairs of stone eyes were watching me from above.

What enhanced my pleasure in Glasgow's plethora of statues, gargoyles and ornament on the walls and roofs of its grand buildings was the fact that the city's residents seemed oblivious to their existence. Hardly surprising, since our necks aren't designed to tilt back for any length of time. We instinctively walk looking down to see where we are going.

For many years I have thought about different ways to share this visual feast with a wider audience. Eventually, it was clear that a book with beautiful colour photographs was the best way to draw attention to this neglected aspect of Glasgow's architectural heritage.

Other studies have been published before. We're in great debt to Ray McKenzie's wonderful and exhaustive *Public Sculpture of Glasgow,* published by Liverpool University Press in 2001, which proved invaluable in both identifying subjects we didn't know and important facts that could inform the reader.

But this book is a very different animal. While *Public Sculpture of Glasgow* is a serious and comprehensive academic study, the focus here is visual. David Barbour has used his 20 years in architectural photography to show off Glasgow's hidden assets to the very best effect. Additional images have been provided by Mike Brooke and myself. We have also avoided the jargon of architectural study so that the annotations at the end of each chapter are easy to understand.

This is very much a personal selection, with an emphasis on secular architecture (with a few lavish ecclesiastical exceptions). There's plenty that has been omitted for reasons of cost, brevity and in some cases photographic accessibility (for example the glorious Buck's Head Building on Argyle Street has been shrouded in scaffolding during the entire production period of this book).

We make no apology for also using our images as a means to inspire some of Scotland's best writing talent. It's a pleasure and privilege to be able to commission Colin Begg, Jim Carruth, Sophie Cooke, Vicky Feaver, Graham Fulton and Kona Macphee to write poems on the subject of Glasgow's architectural decoration. These poems provide moments of reflection on the artworks themselves. But they also look at the historical context in which a majority were created, during the boom years when Glasgow was the 'Second City of the Empire' and how this informs the way we view the city and ourselves today.

This is a book to enjoy, to pour over, to keep, to pass on to others, to follow like a map. We hope you find it a way to rediscover our world class architectural heritage, regardless of whether you're local or a visitor to this great city. Most of all, we hope you hear the cry, Look Up Glasgow!

—**Adrian Searle**

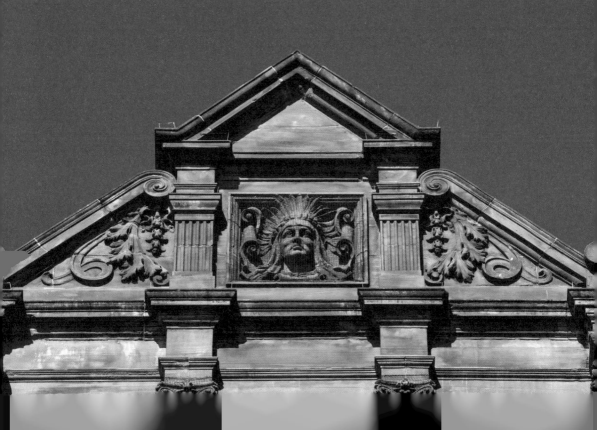

LOOK UP GLASGOW
CITY CENTRE

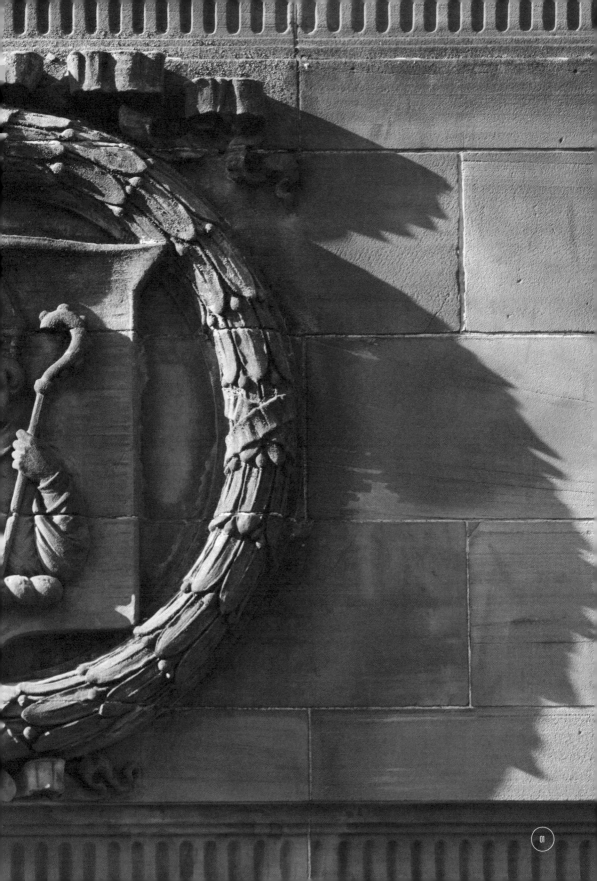

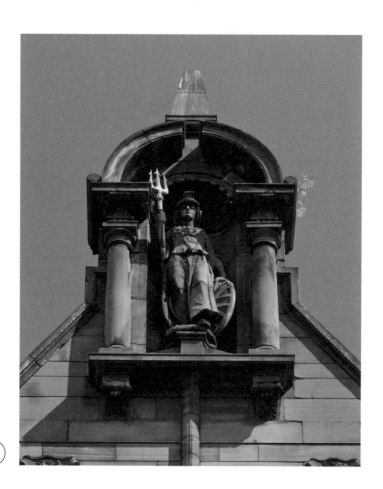

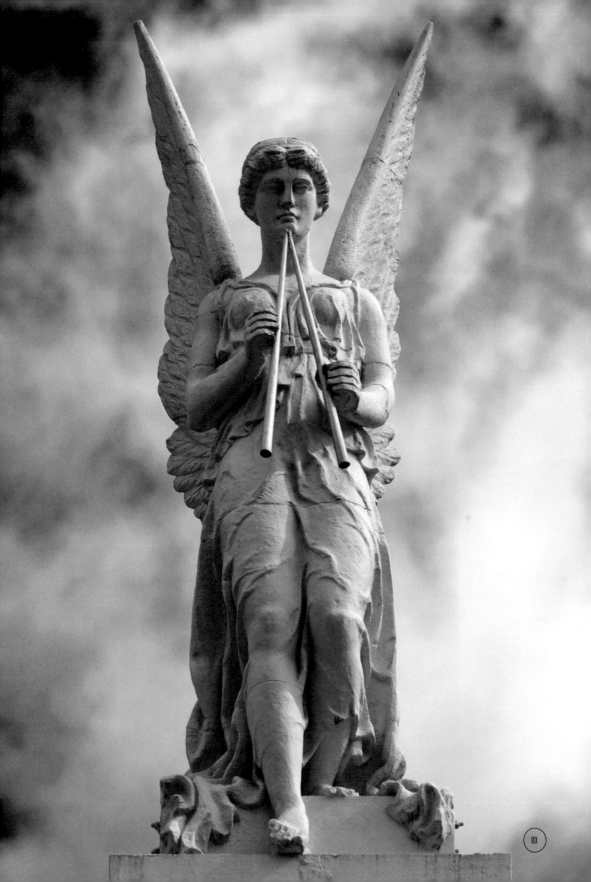

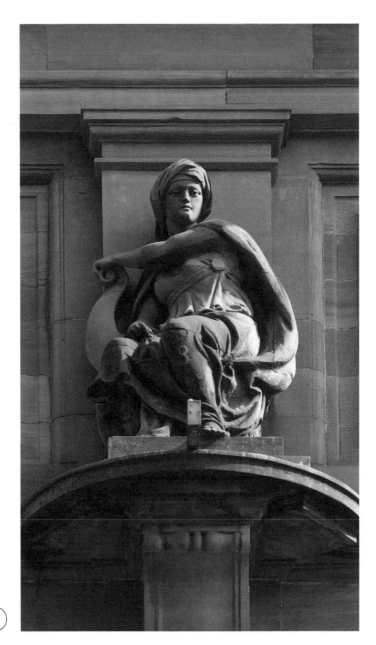

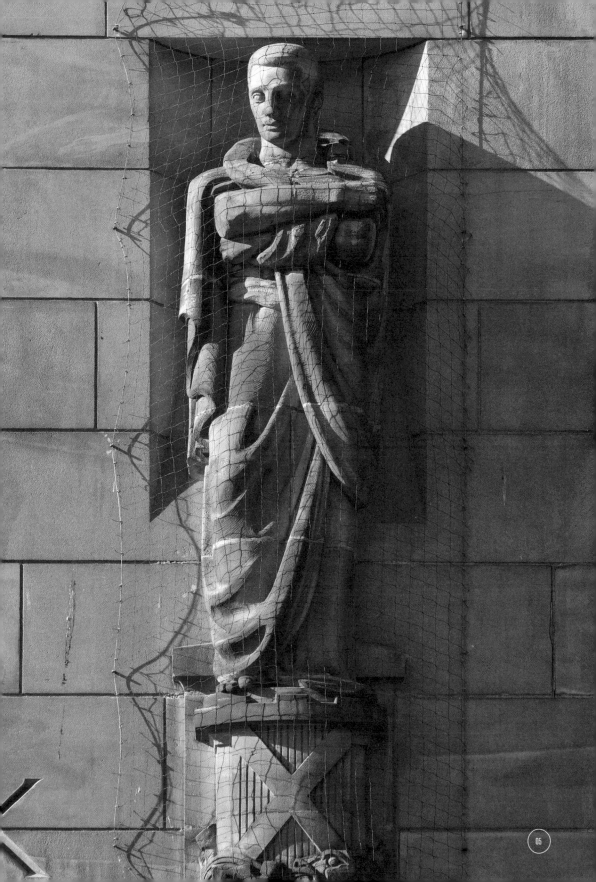

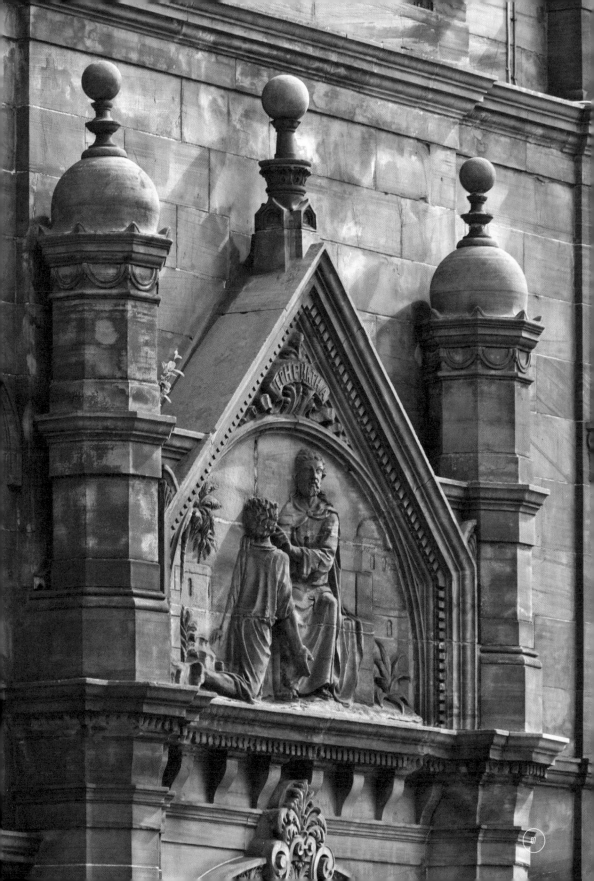

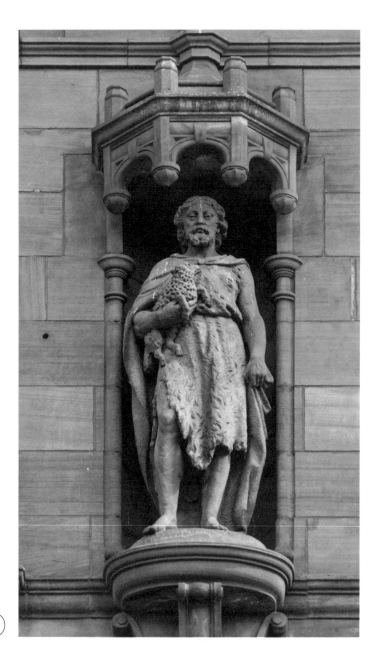

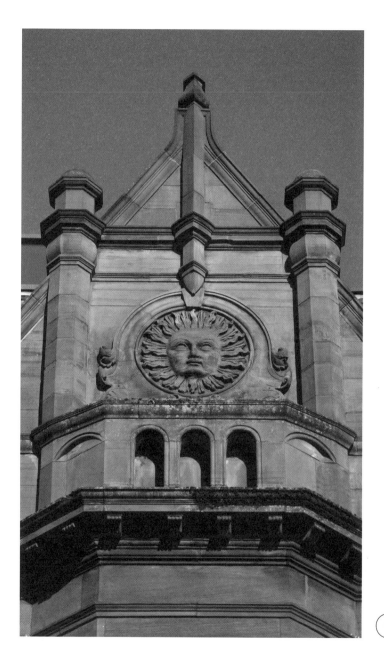

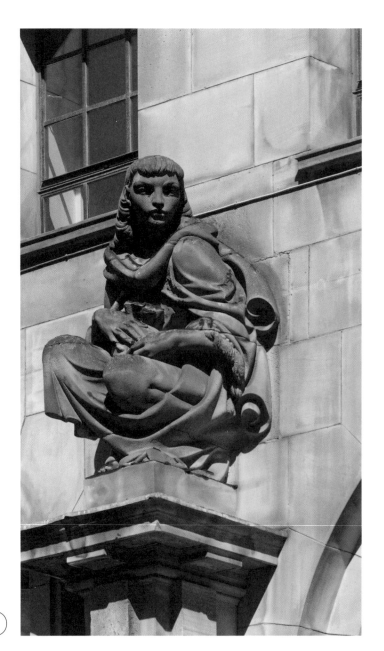

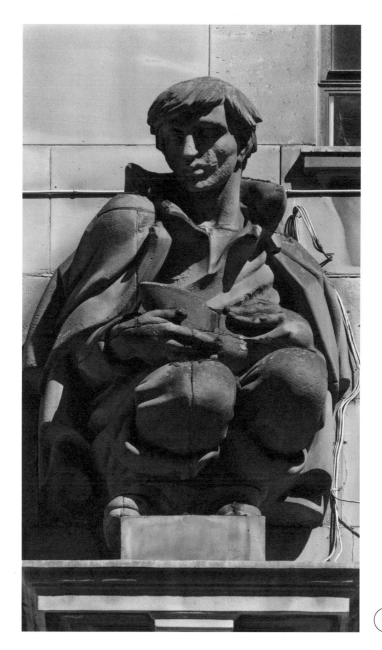

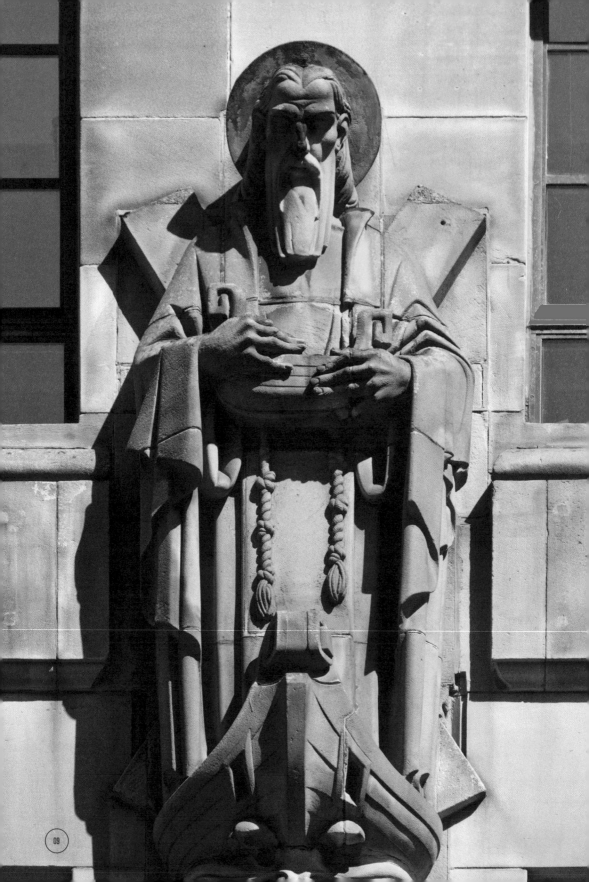

The Derelicts

Kona Macphee

They beg along the inner city miles,
these empire's orphans, each a hefty waif
of blurring stonework, downward-slipping tiles:
not yet unlovely, ever more unsafe.
Façades and gutters foster tufted plumes
— funereal wild ironies of green —
while rain and roots slip in to higher rooms
and do their wreckers' work unpaid, unseen.
Passing, we buzz with possibility
(Academy of Joy? Some arty den?
A Makers' Market? Haven of tranquility?),
our whimsies ghosting shells with life again:
and yet we never give these failing graces
more than the unlived lives behind our faces.

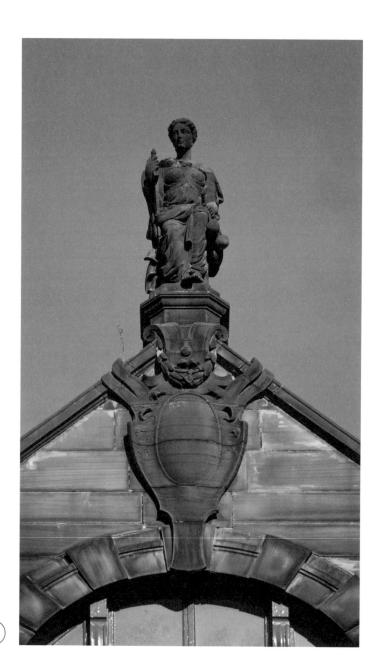

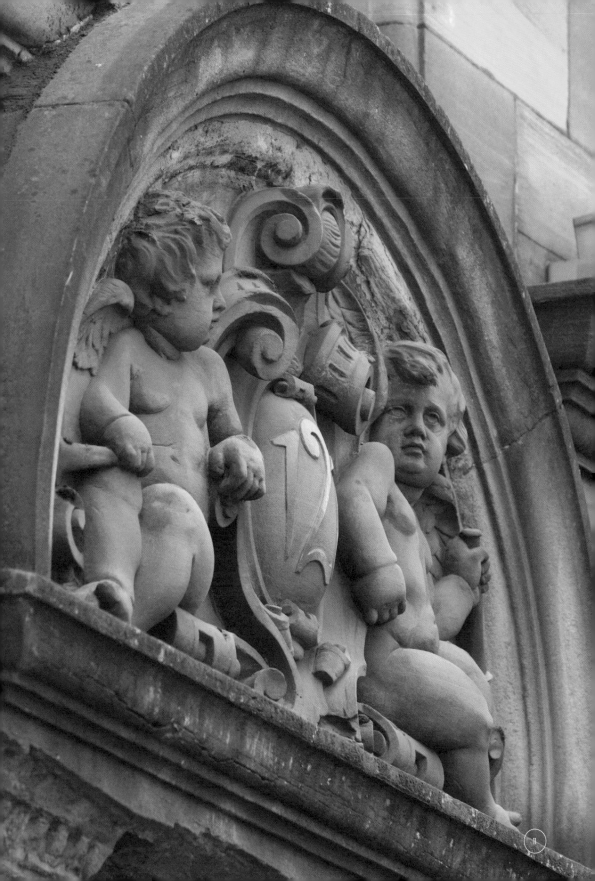

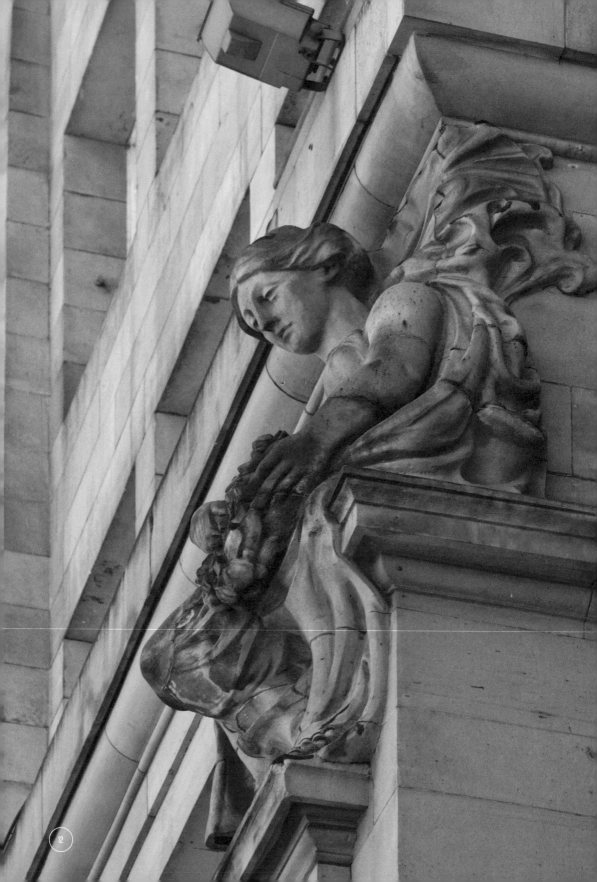

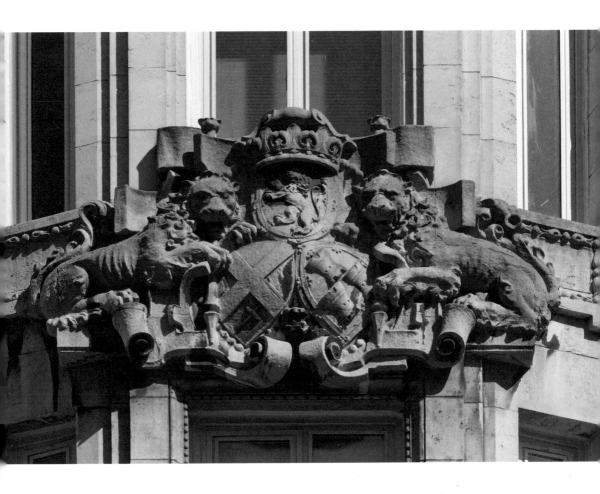

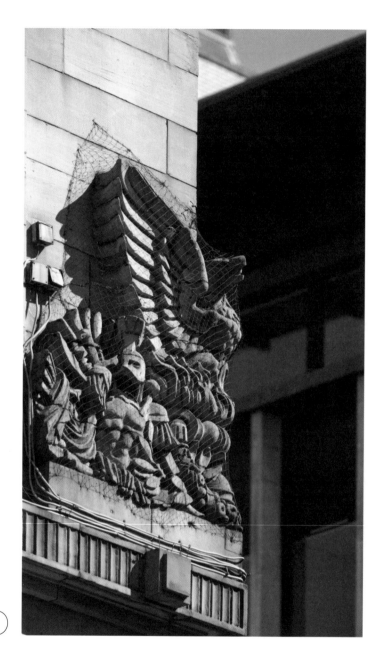

Glasgow album

Kona Macphee

O photographer!
Why this beryl litany,
these cobalt encores?

Blue is for tourists;
a native heart knows snapshots
grey-scaled, street-wise, smirred:

the city, wet-sheened,
resting in its hill-rimmed dish
like a vast glazed tart

a wet mist rolling:
camouflage for the ghost-ships
still haunting old men

summertime downpours:
the river's bygone highway,
the road a river

nightlife parallels:
rain tracks and spaghetti straps;
shopfronts as mirrors

women on a train:
fifties-raucous, trinketed;
splashy umbrellas

a seedling hard-man:
skinny, chippy, jitter-eyed;
sleet-melt on tattoos

a doorway's shelter;
banter with passing soakers:
glasgow smiles better

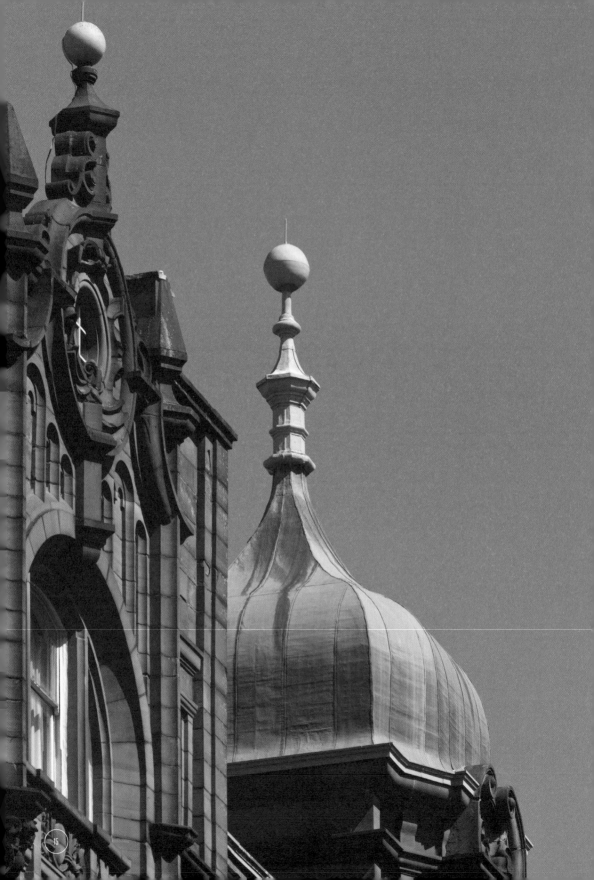

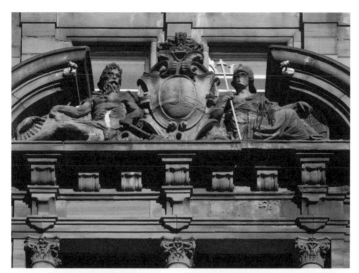

15

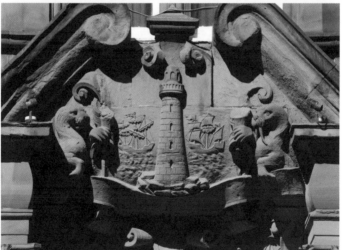

15

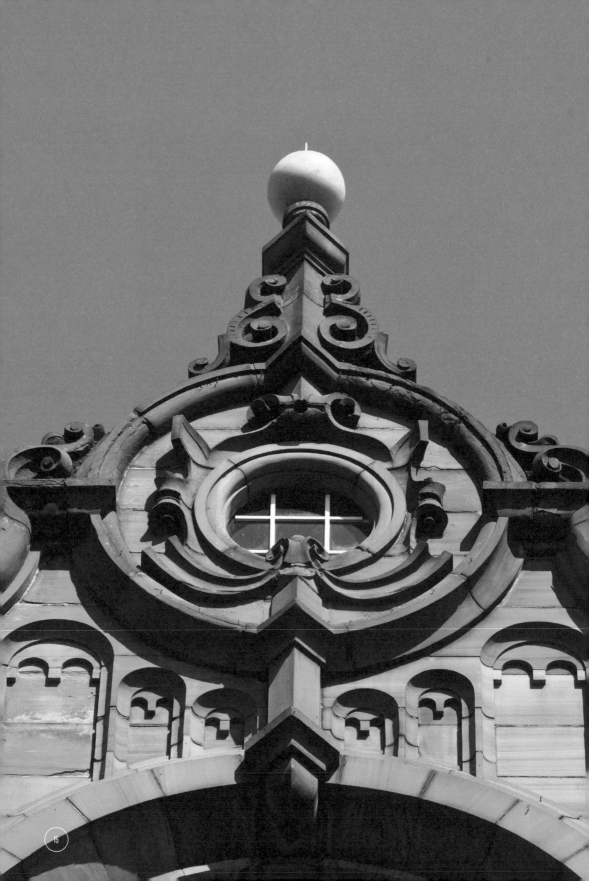

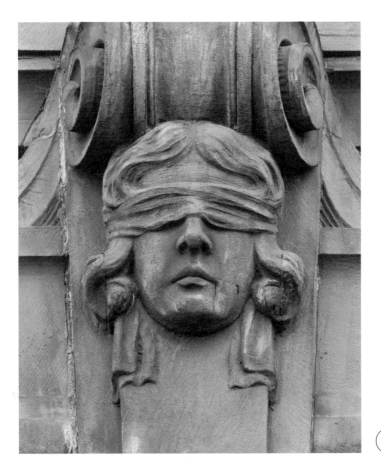

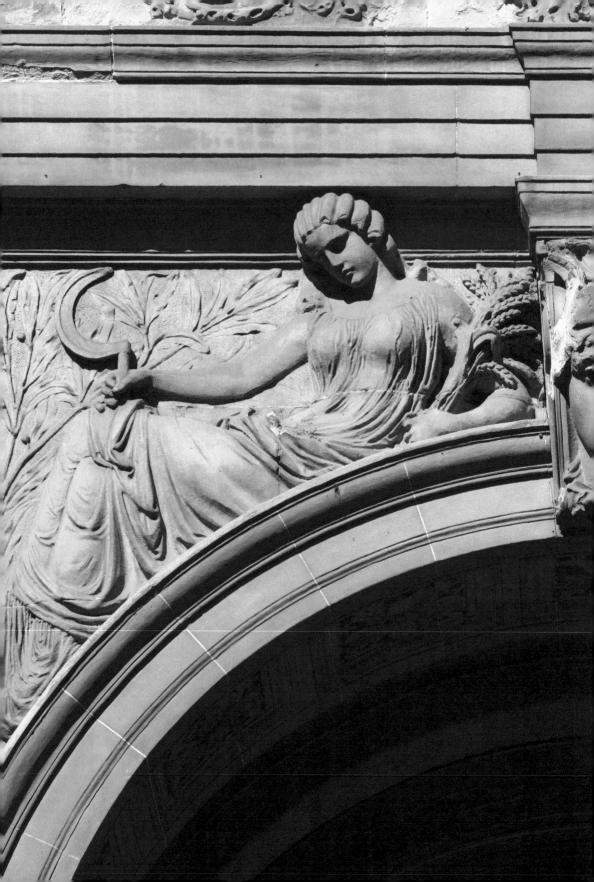

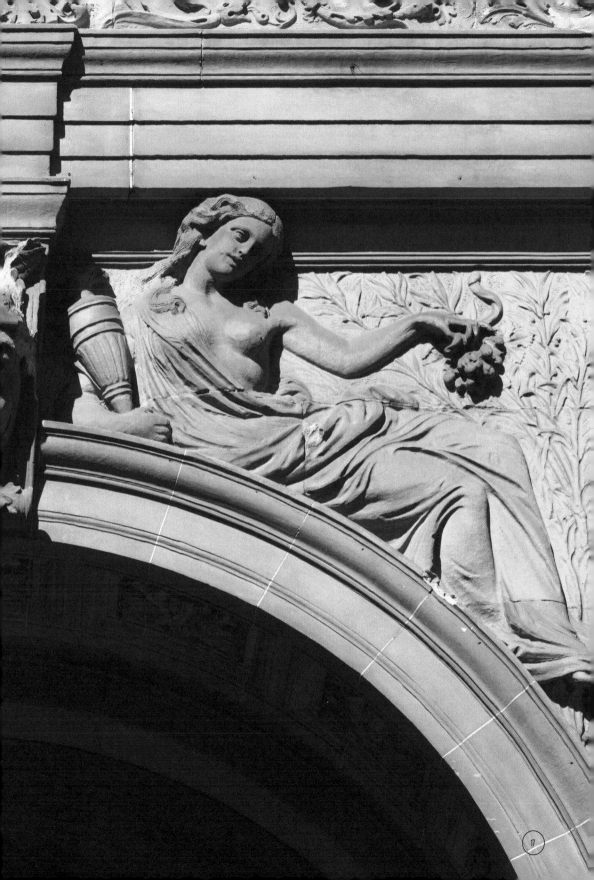

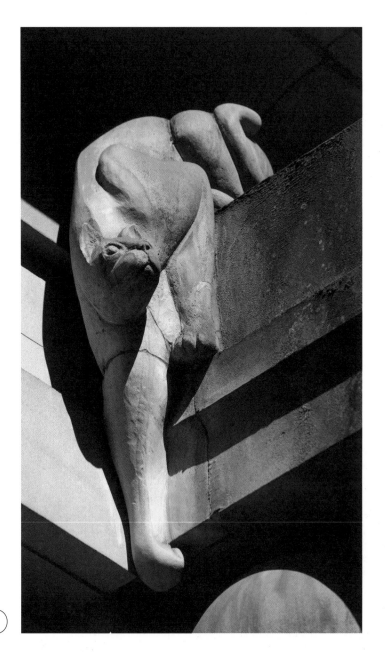

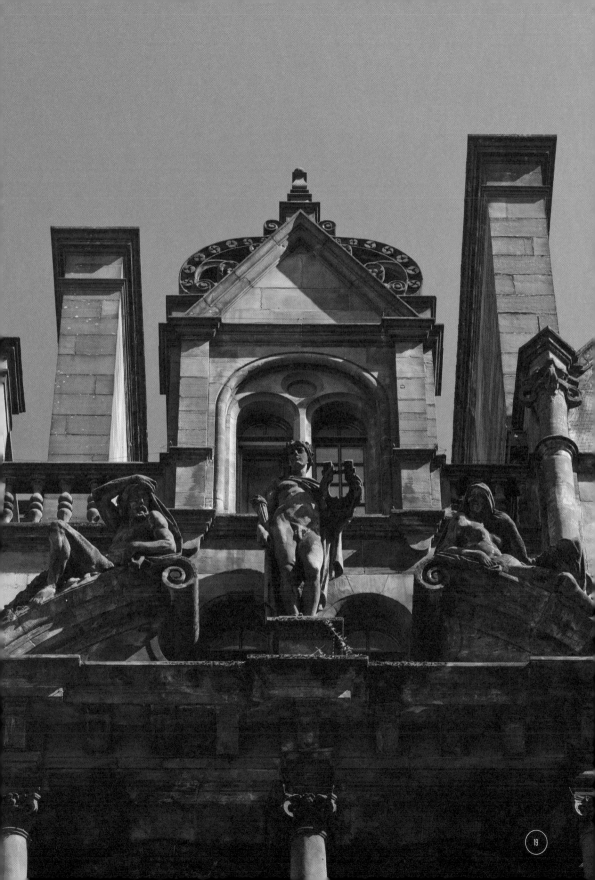

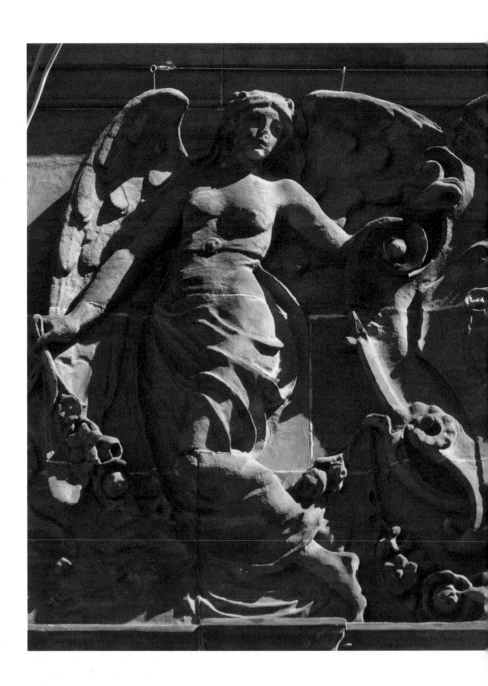

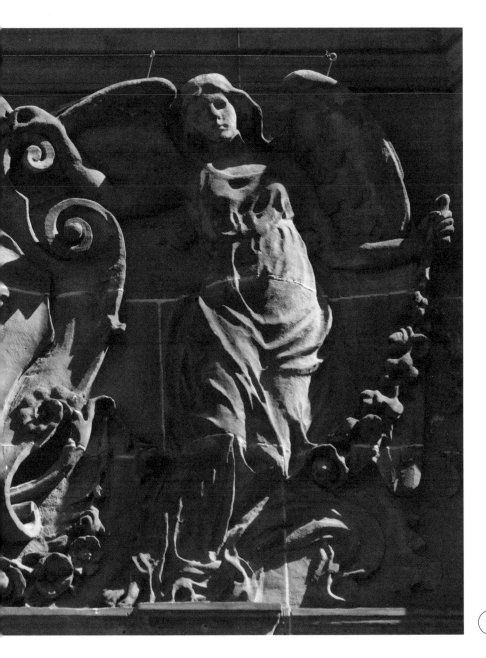

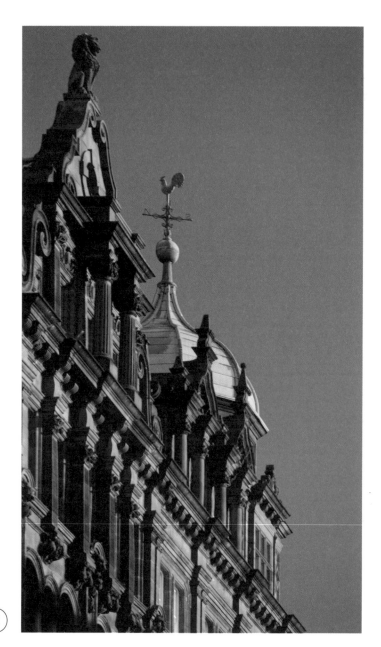

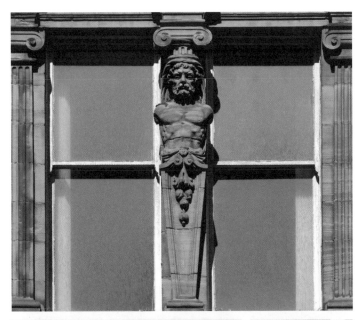

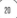

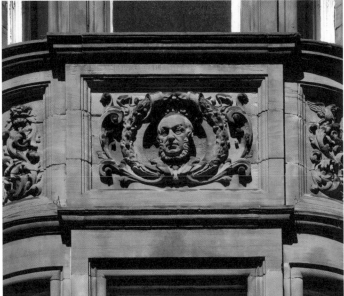

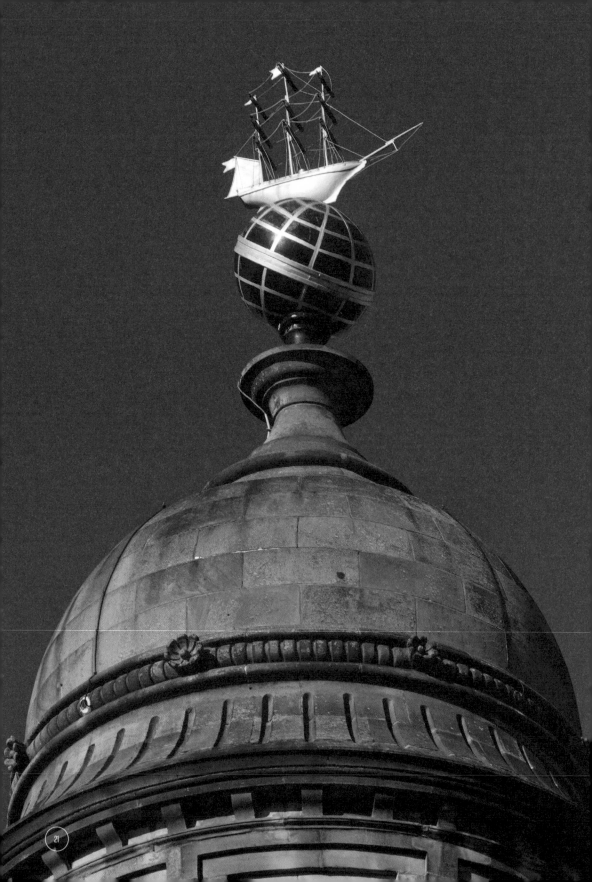

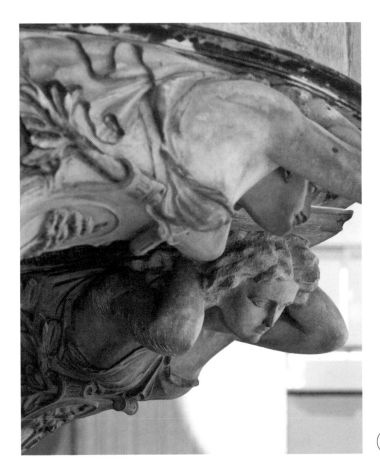

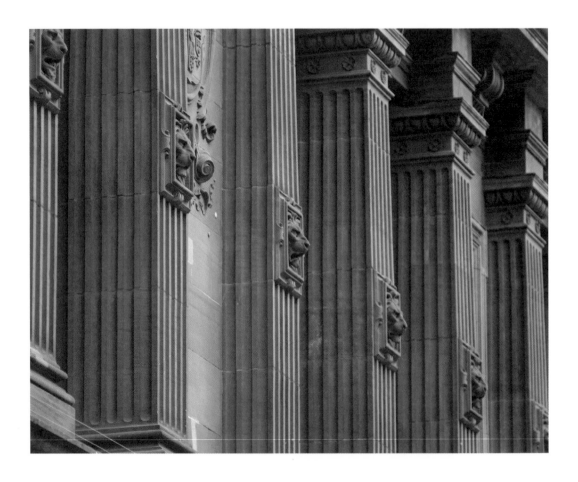

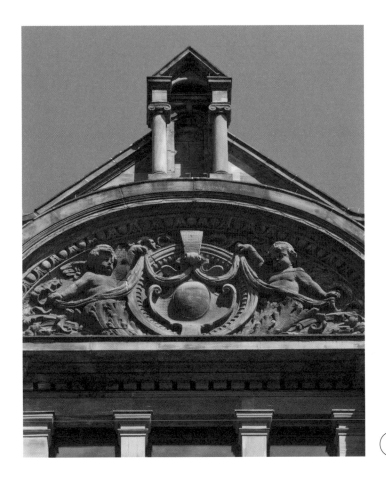

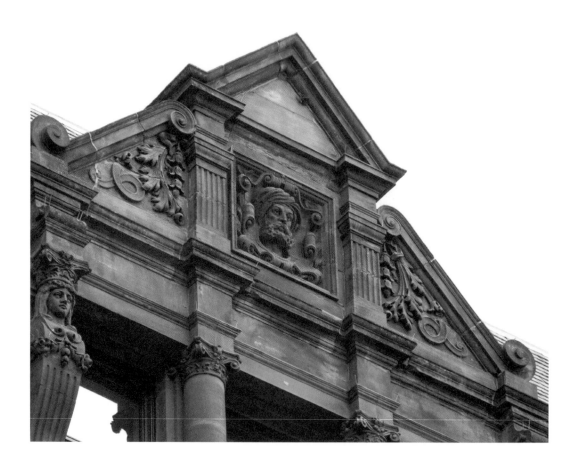

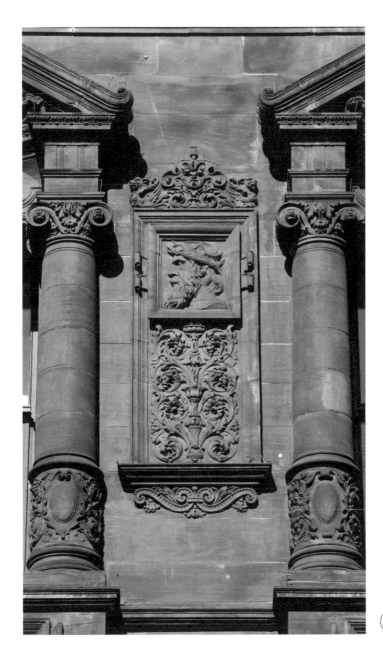

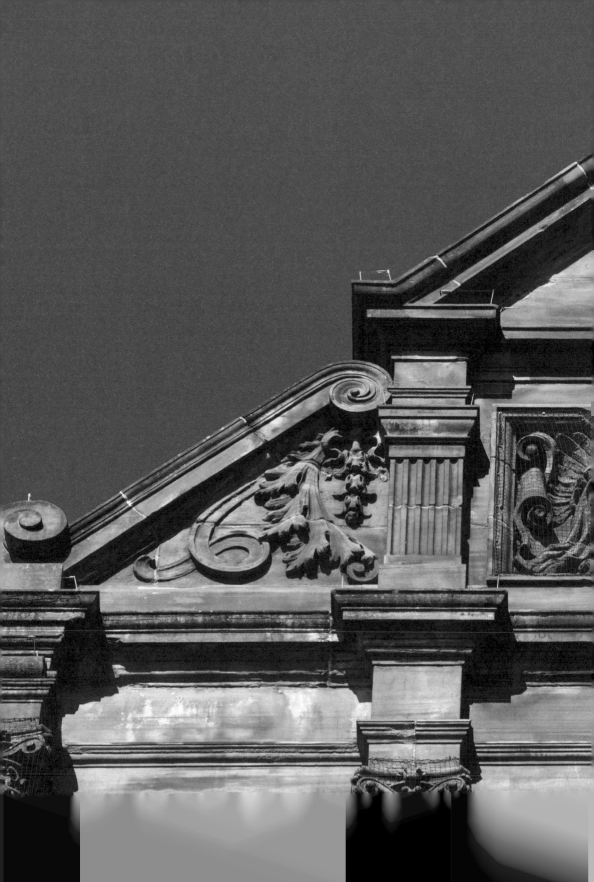

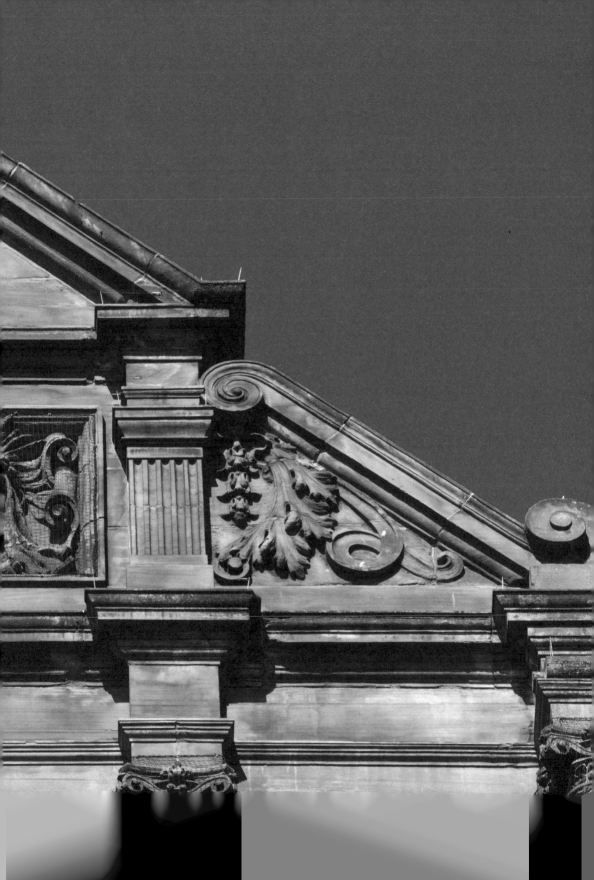

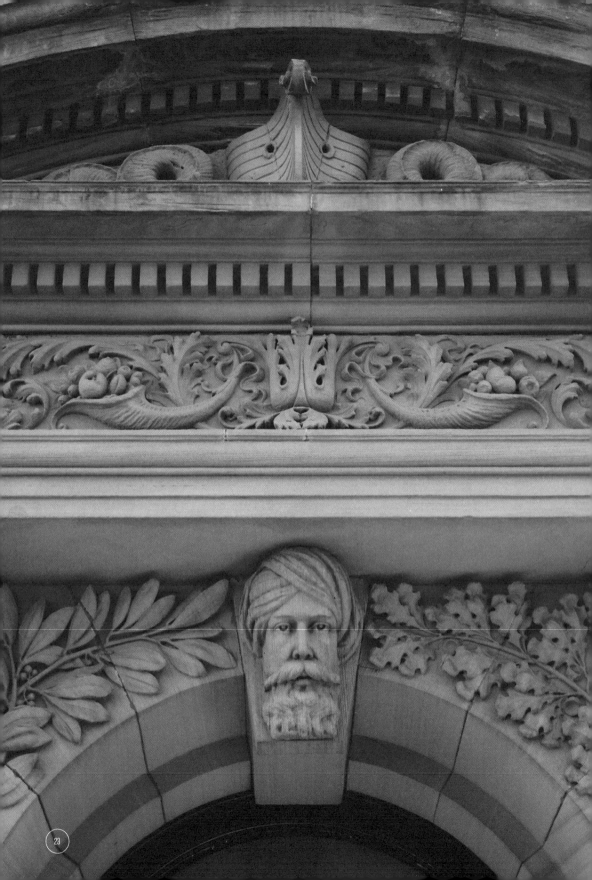

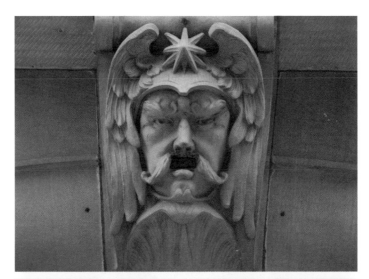

24

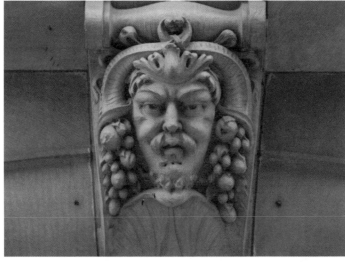

24

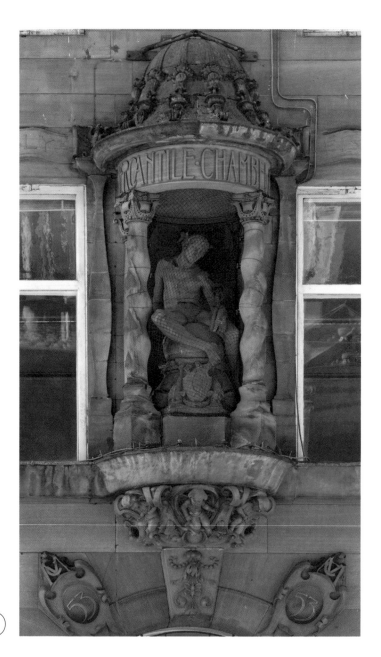

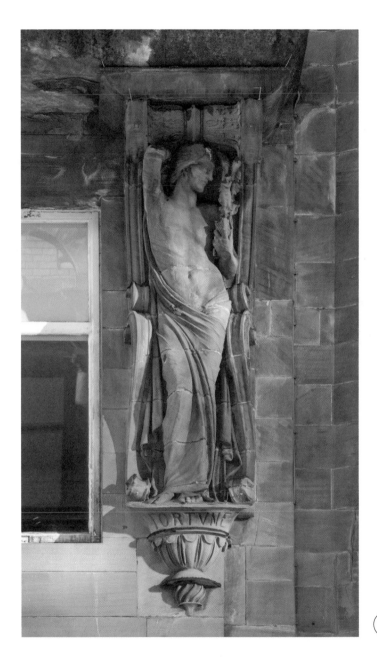

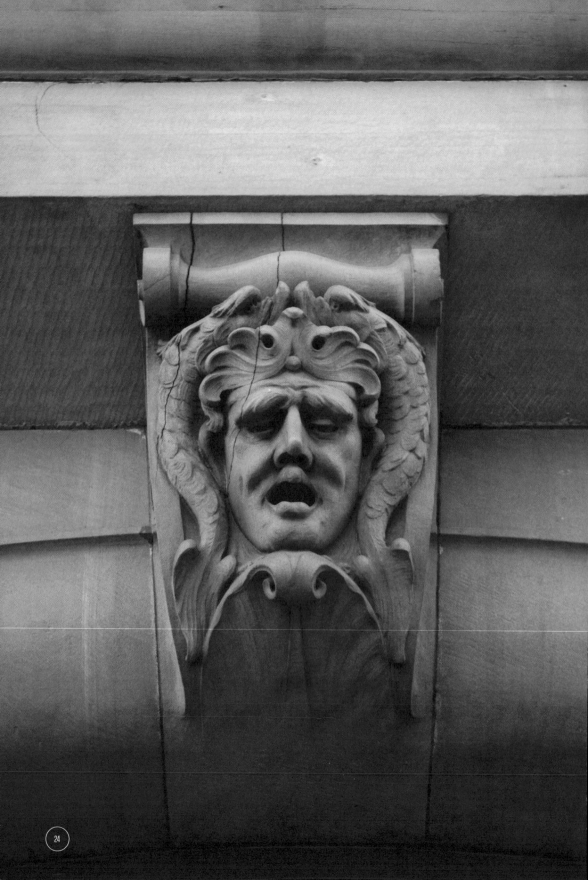

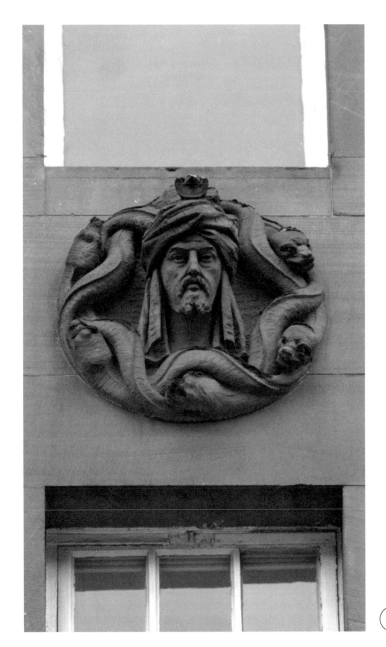

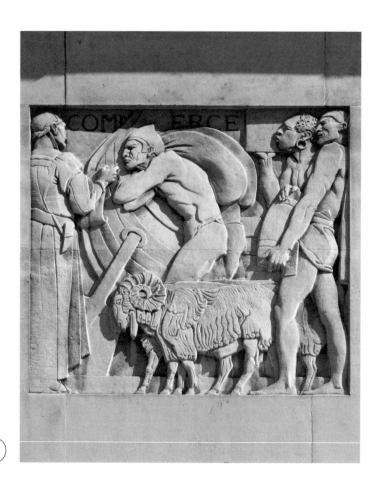

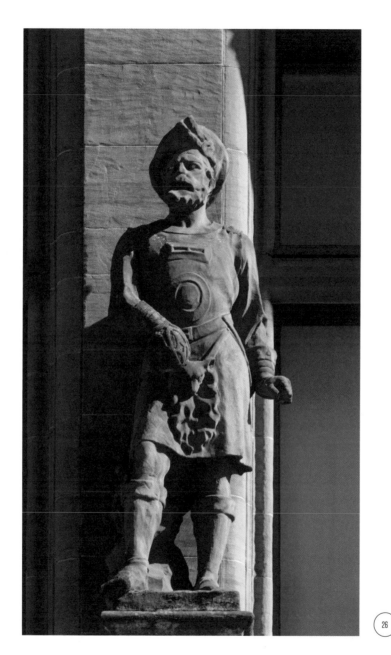

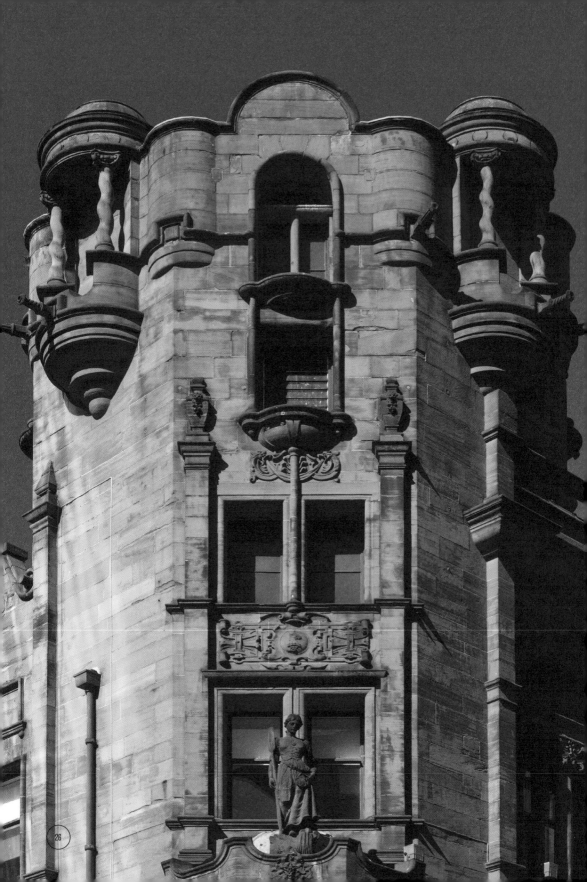

The Postman

Graham Fulton

as I stare up at the face
of a mythical man in pain
staring straight down from a wall
a postman in red coming out of a café
tells me if
I walk down the hill and turn right
into Waterloo Street
there's the most beautiful building
in Glasgow
about twenty yards along
with a FOR SALE sign on it
and clustered people smoking
at the foot of the steps
beneath two jaunty
turbany-kilty-Robin-Hood-type figures
who seem to be ready to start dancing
any moment now,
and there are six small smiling heads,
and at the very top,
if you shield your eyes from the sun,
there are bits sticking straight out which look
like Elephant trunks,
and it's a real shame
what they've allowed to happen
to the building,
and when I go and look
he's absolutely correct

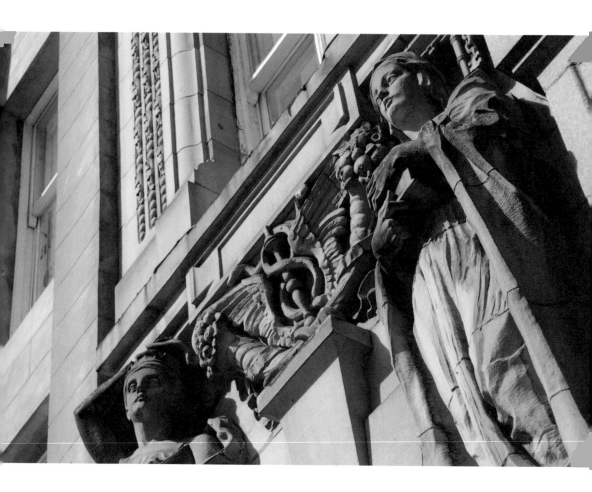

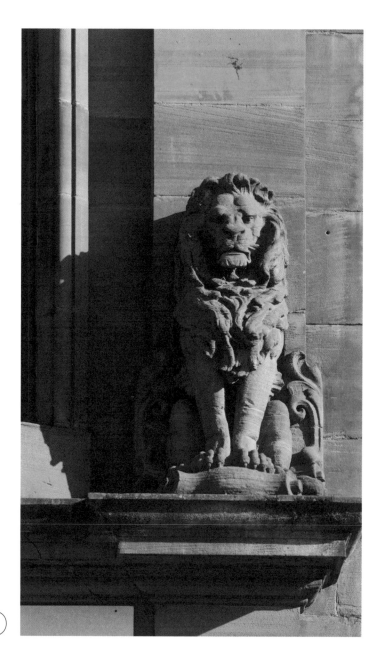

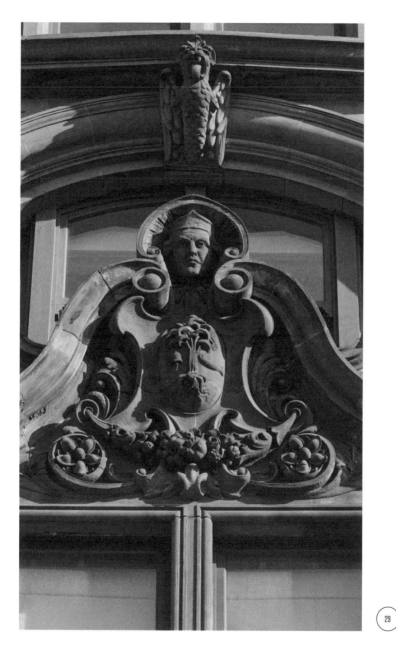

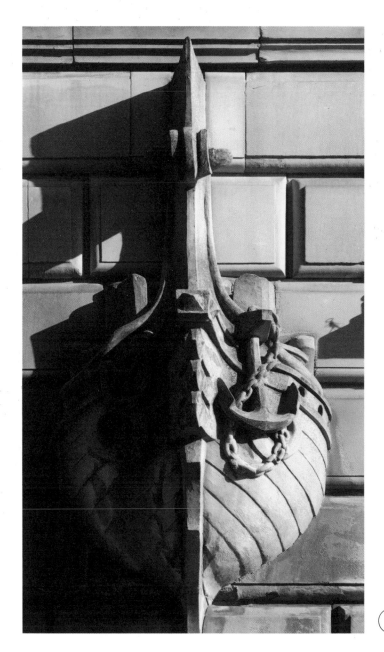

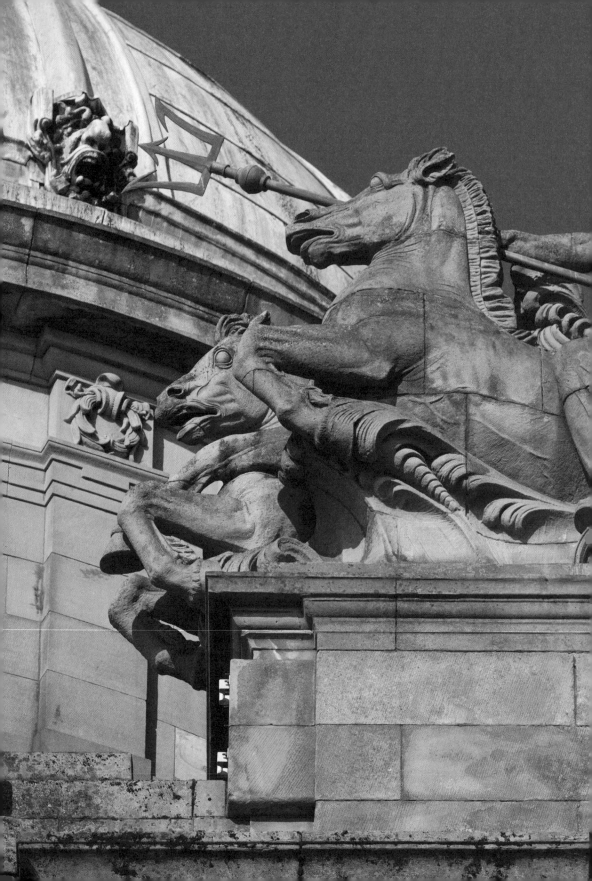

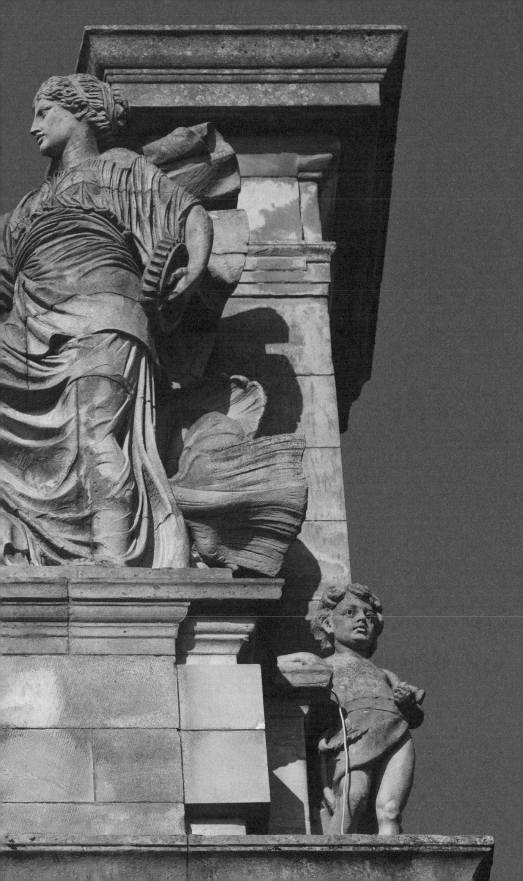

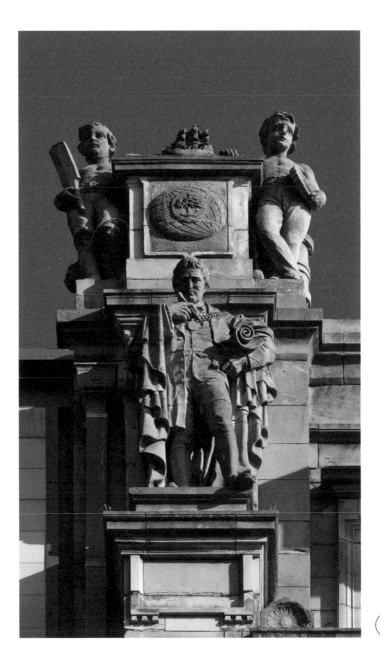

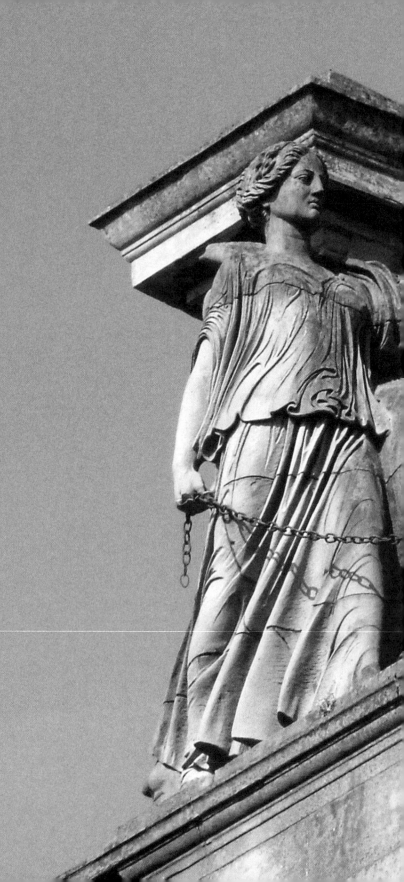

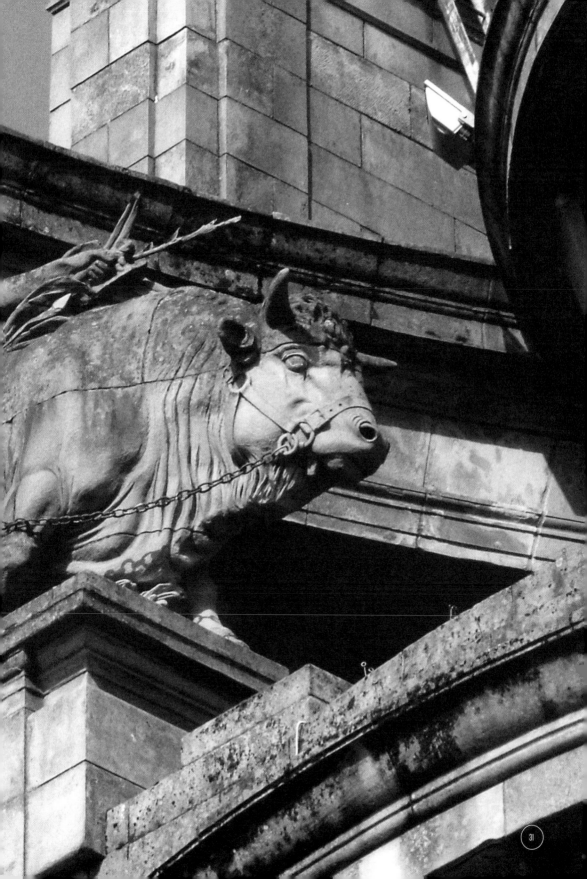

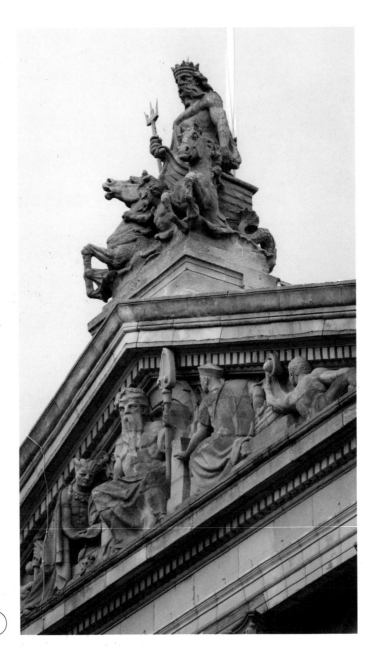

31

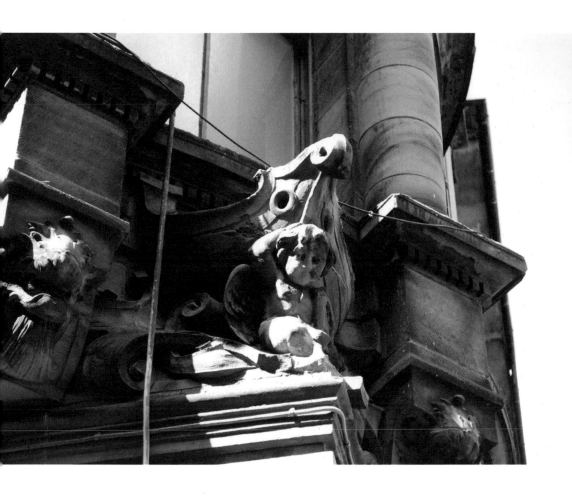

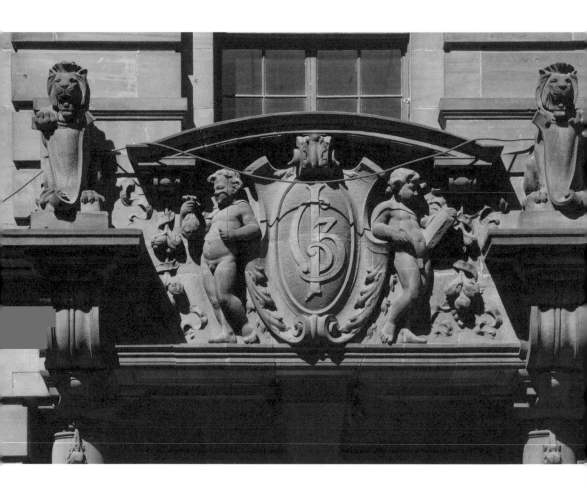

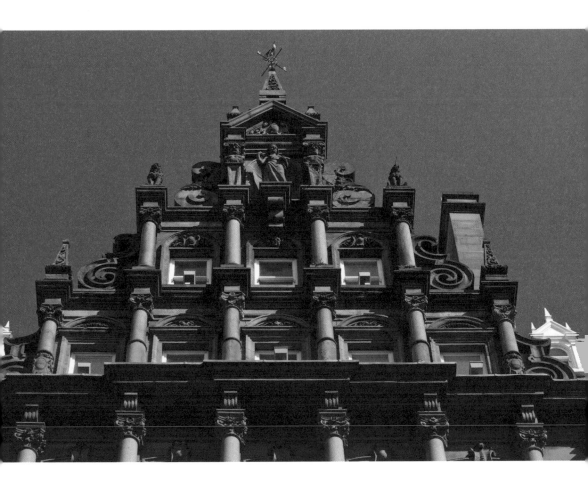

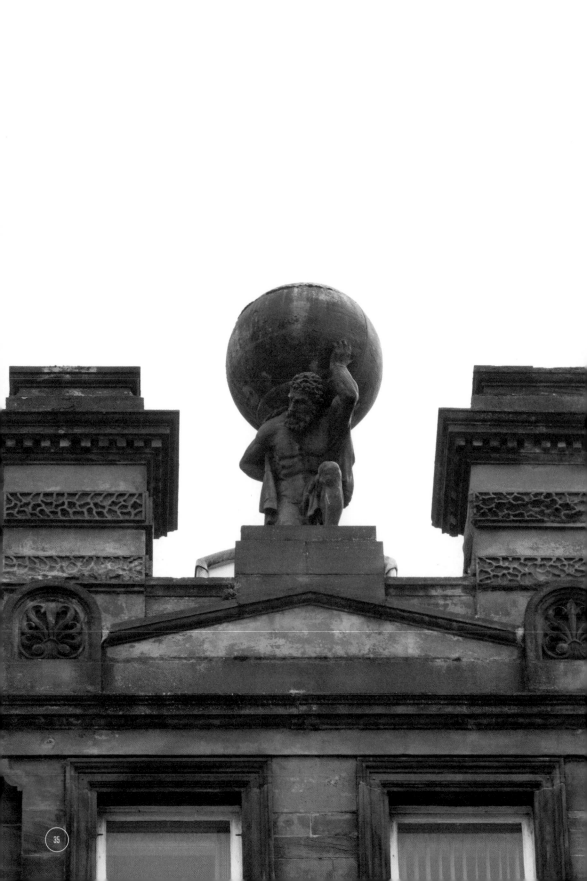

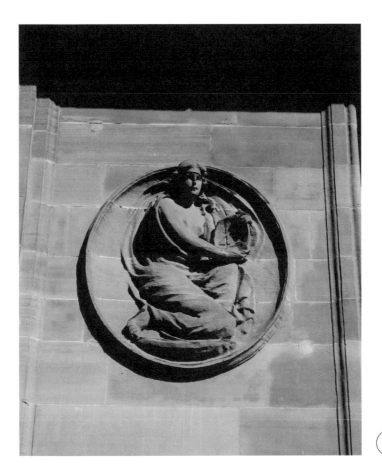

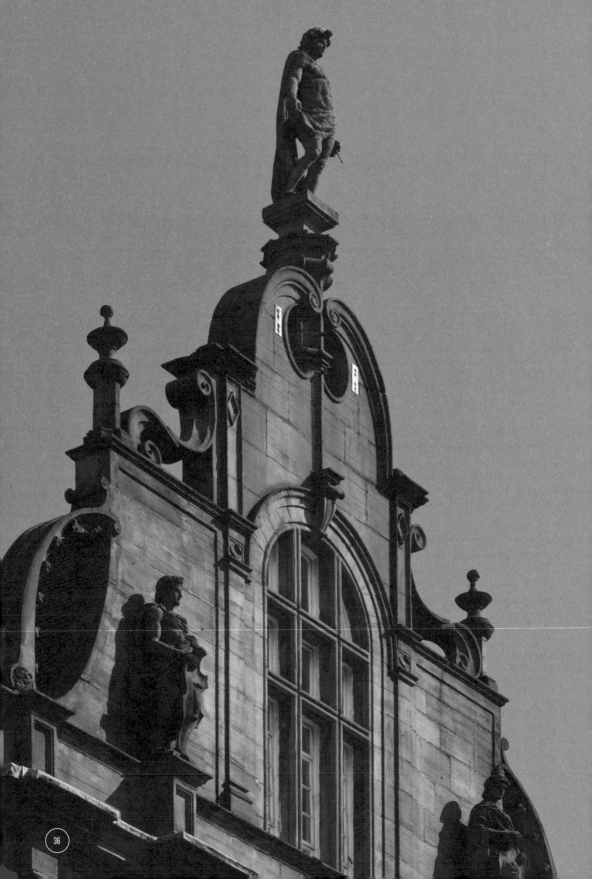

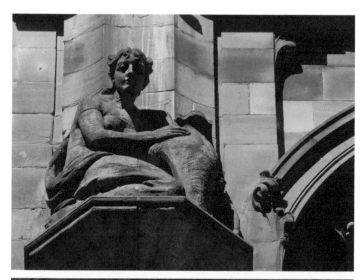

37

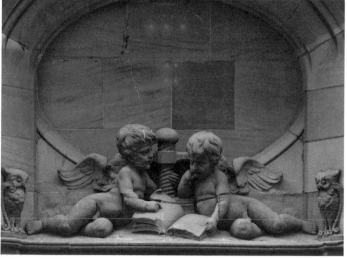

37

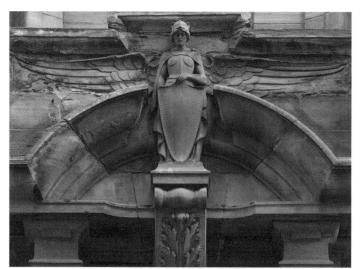

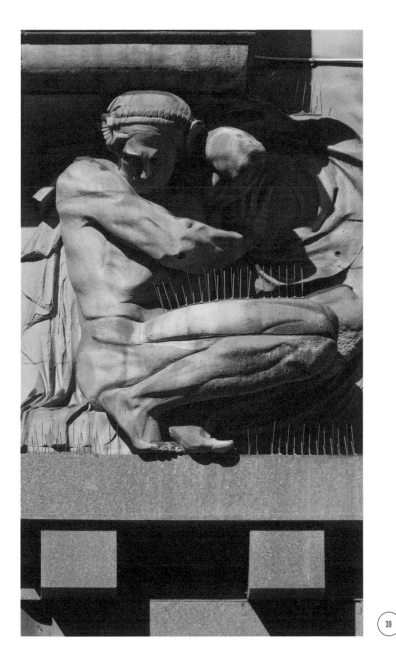

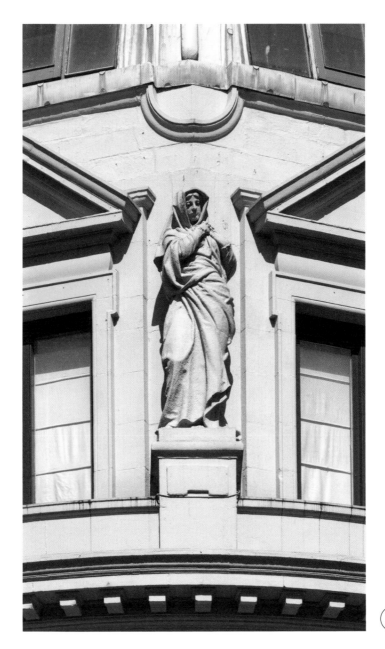

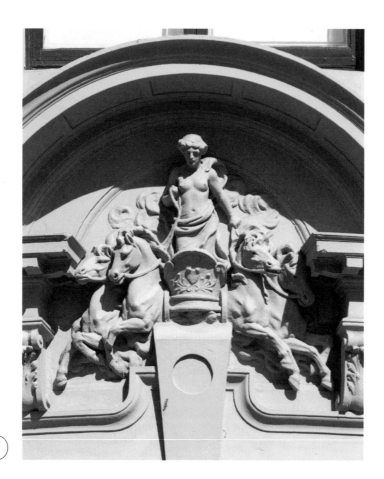

41

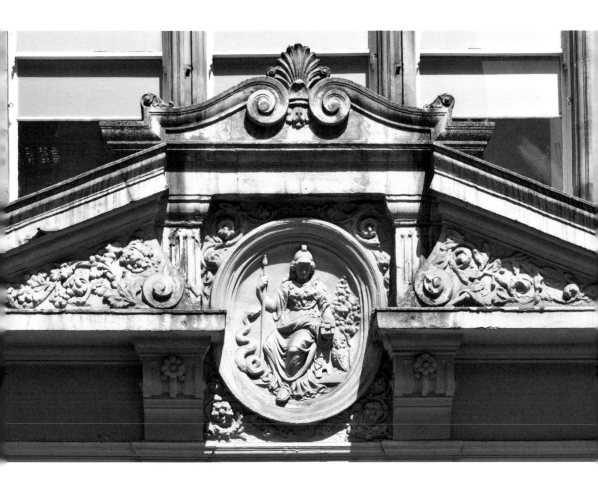

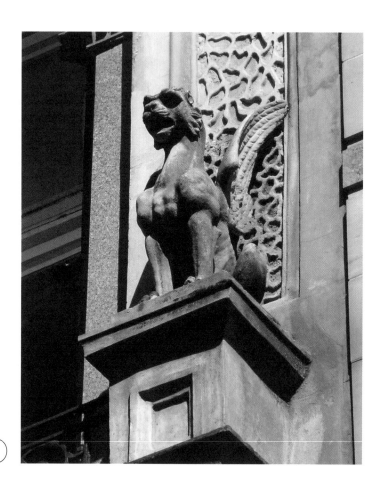

43

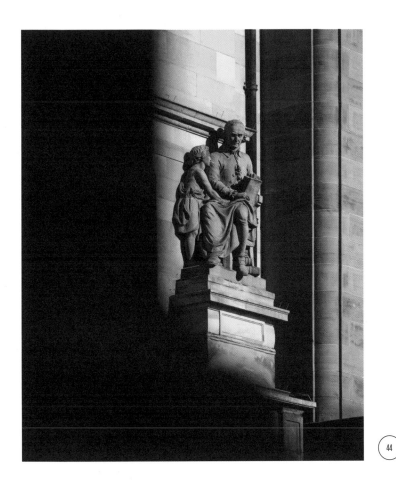

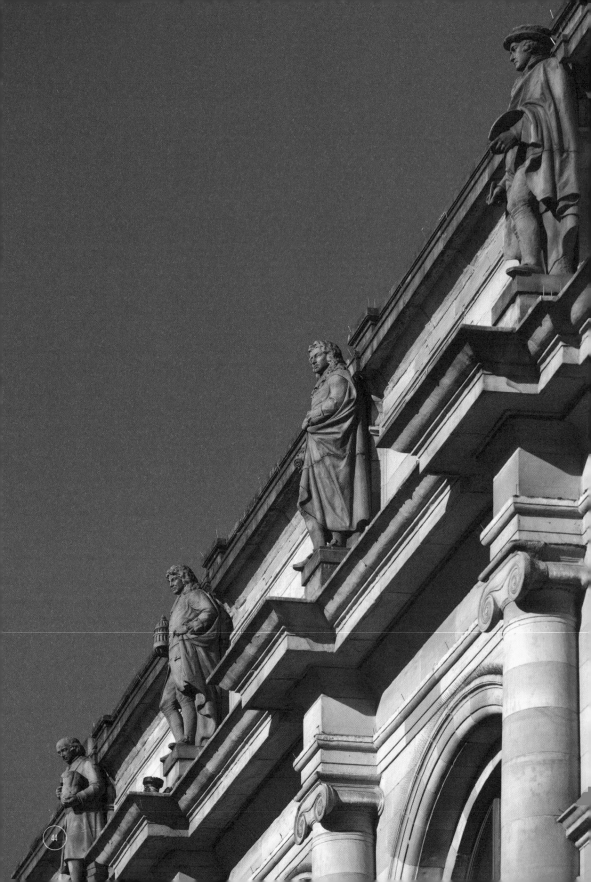

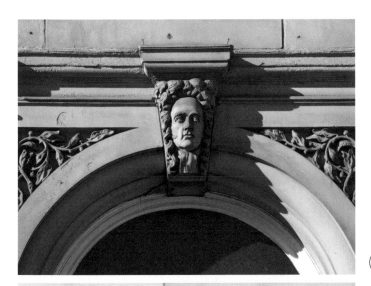

45

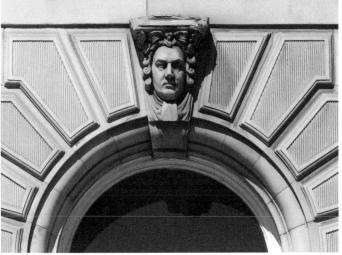
45

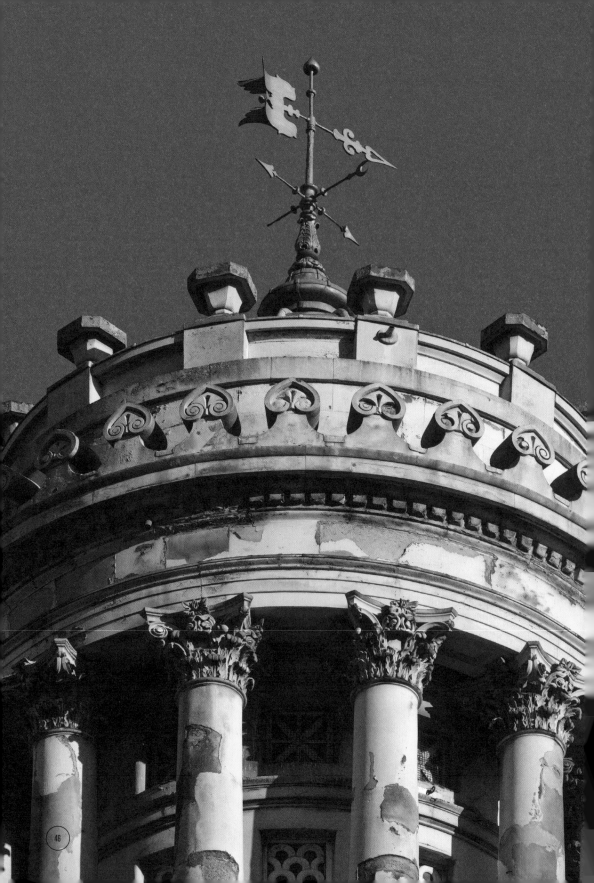

The Details

Graham Fulton

I'll know when I see it

a secret
hiding at the edge of the details,
 overlooked,
a suggestion of a feeling that says
Here is what it's all about,
Here is what we're left with

serpents coiling out of stone,
classical maidens with glorious breasts,
a woman with wings playing two flutes
at the same time,
fruit, fronds, symbols of abundance
on the affluent walls of mansions and halls,
The Baltic Chambers,
The Lion Chambers,
a man crouching behind a net
to stop things getting in, things getting out,
 a secret
skulking at the margins of the mind

the ubiquitous prows of ships
slicing through trade winds,
the merchants and moguls and magnates,
a naked child with its face erased
astride a seahorse,
I'll know when I see it, the key,
the shapes that we believe we should take,
the grumpy face of an Argonaut beast,
Neptune dripping fish from his curls,
 gills and goddesses,
scrolls, swirls, expressionless men
supporting the great weights
of banks converted into boutiques

columns and tridents
and urns that belong in a cemetery,
bellows of brutal wealth and prosperity,
Dickensian men called Baird and Donaldson
glowering down, the names
 AYR and PAISLEY
above a casino,
entwined initials, coats of arms,
the instruction LET GLASGOW FLOURISH,
it's all in the details of time and space,
it's all in what isn't there anymore,
the promises
JUSTICE WISDOM CONTENTMENT,
the fading traces of obliterated INSURANCE
and WHOLE and THE something
 or other,
 still visible
where they used to be

a paint-caked pair of trousers
 draped over a ledge,
an imagined silent face
at the attic window
of an unhappy warehouse

 Here is what it's all about,
 Here is what we're left with,
the secret waiting to be found,
 layers

of what is gone and what is waiting to go,
empires that rose, waiting to fall

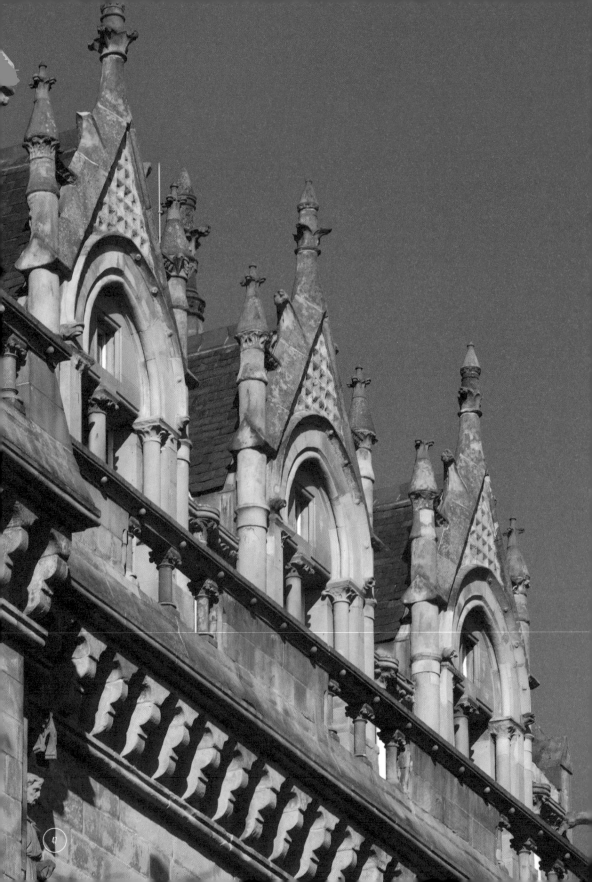

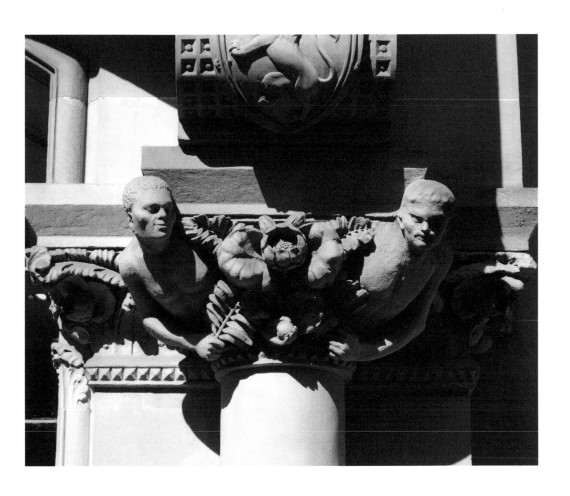

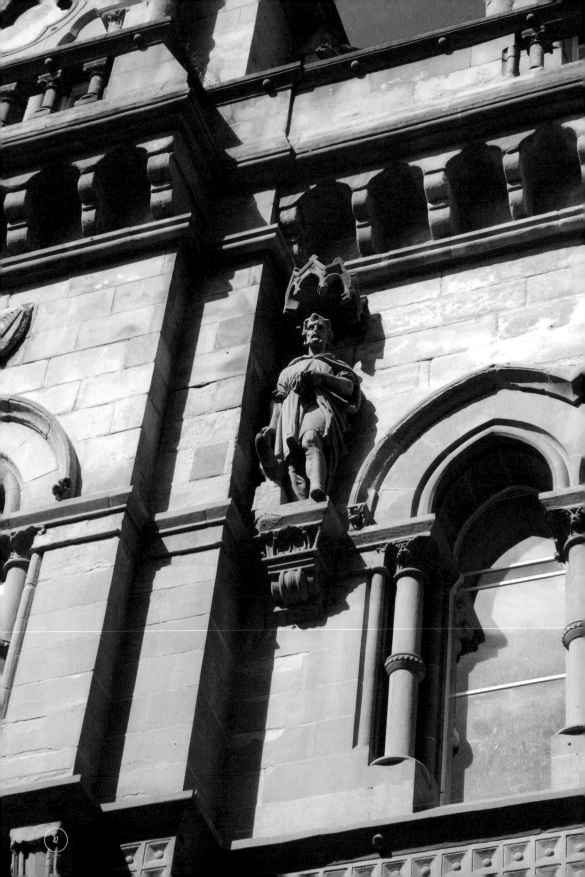

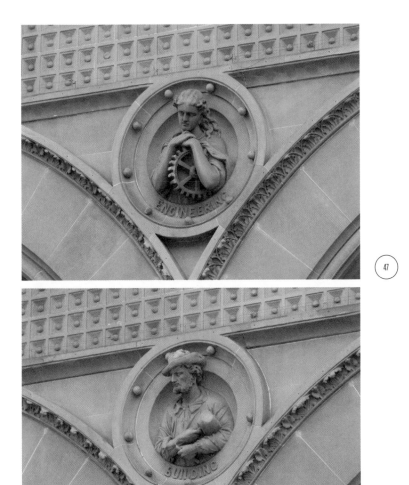

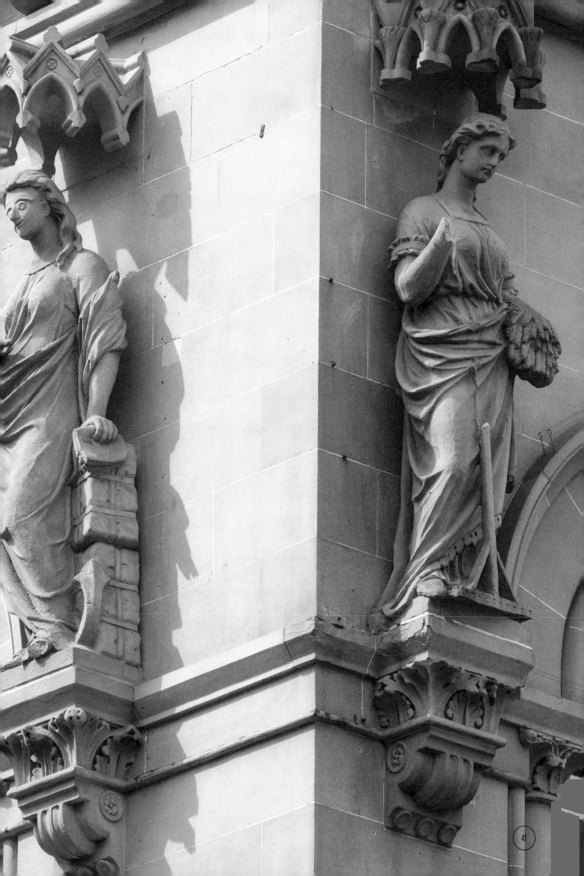

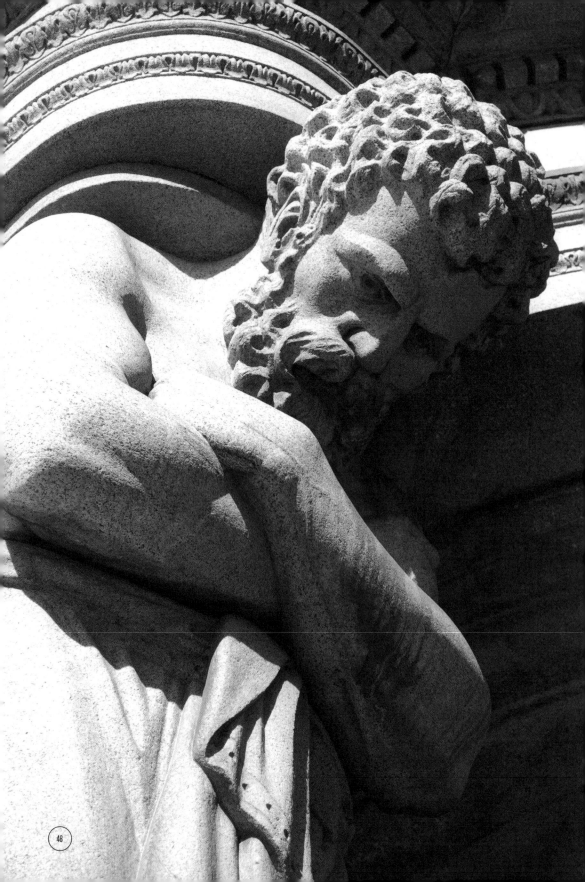

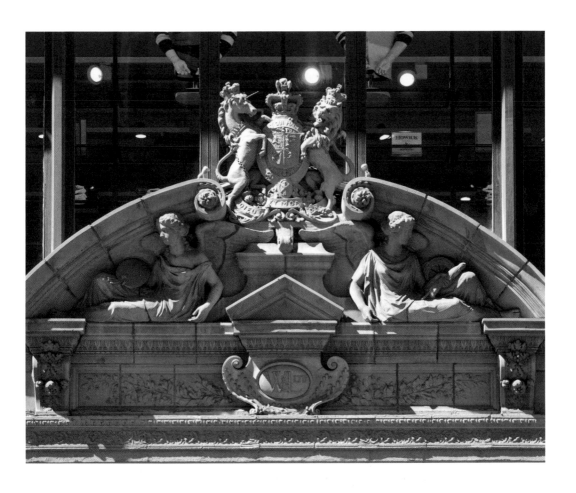

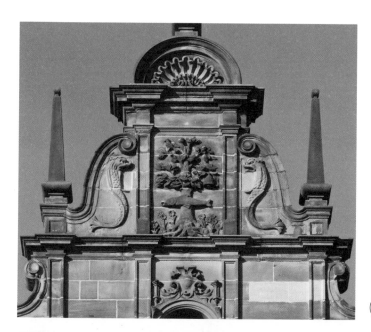

49

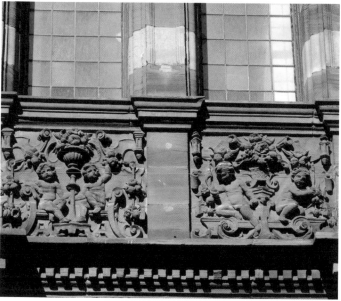

49

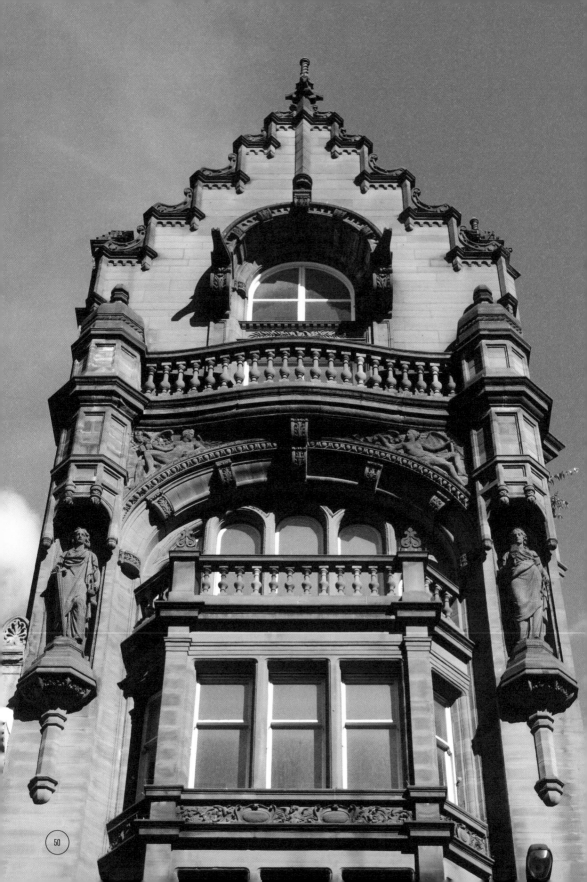

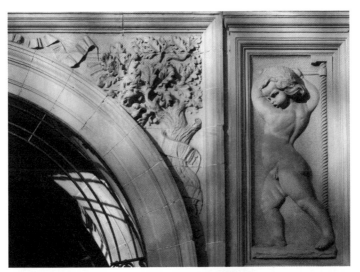

51

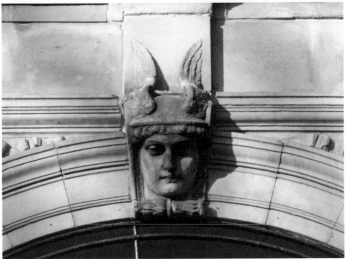

51

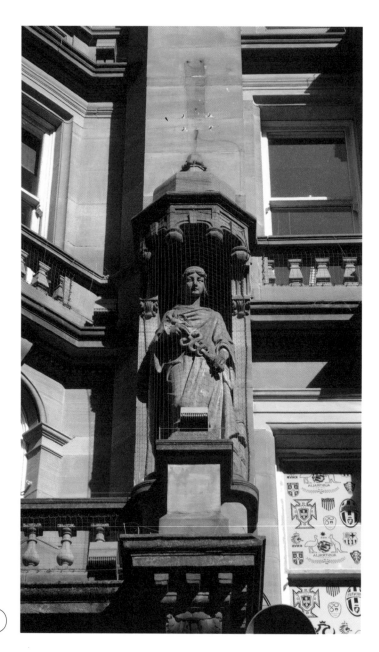

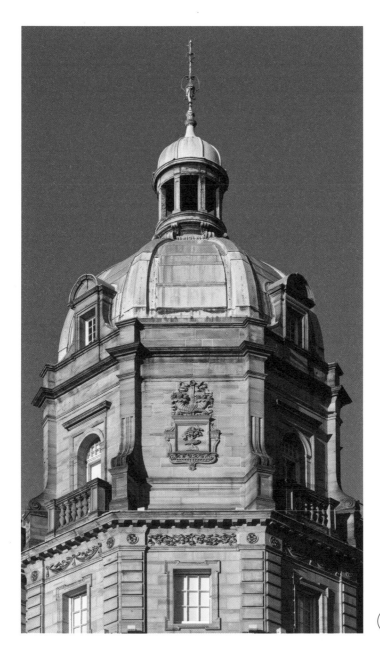

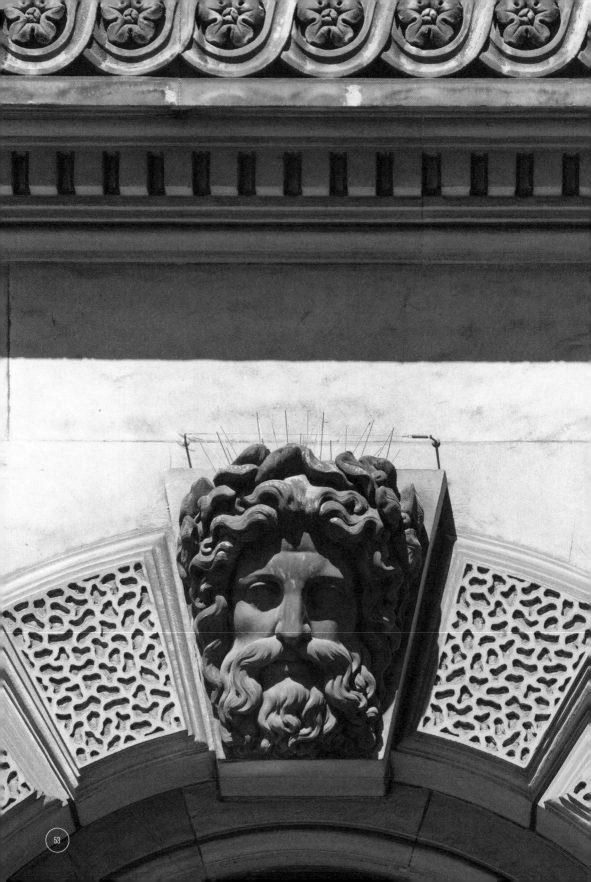

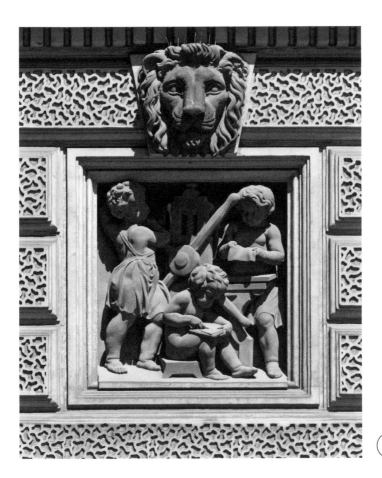

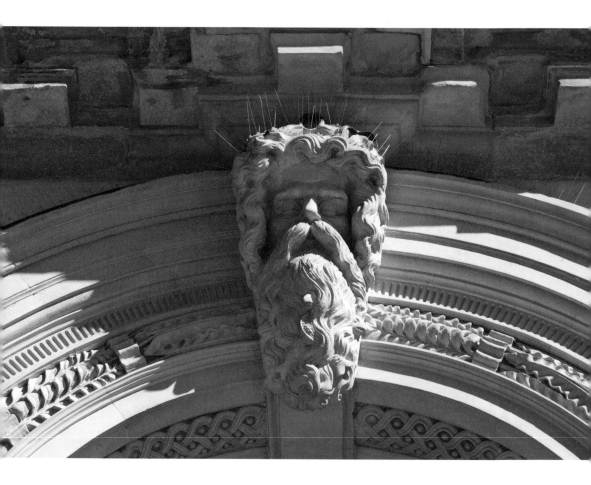

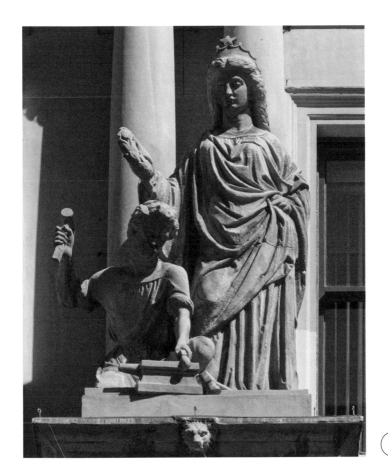

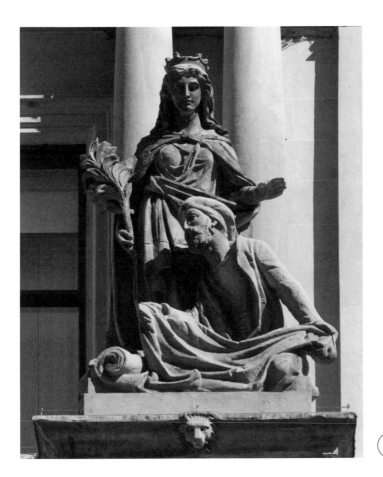

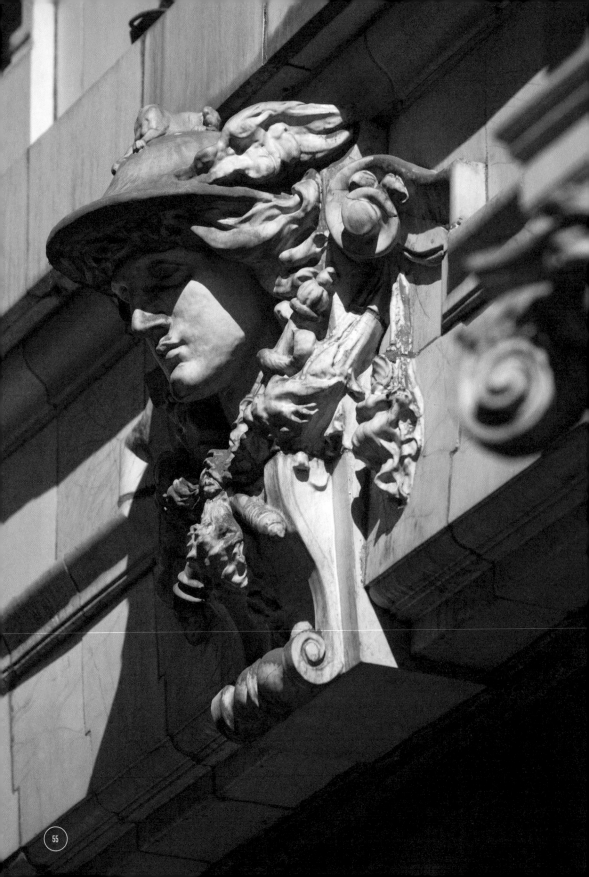

Mercury is tired

Colin Begg

Mercury is tired
from his laurels
right down to the winglets of his ankles.

That running, all day,
doing the messages

working trades
against the grain.

Above the sleeping street he longs
for a handsome courier
with fixed-gear muscles,
to lay flat his arms
to ease his own calves
with Morpheus's dreams.

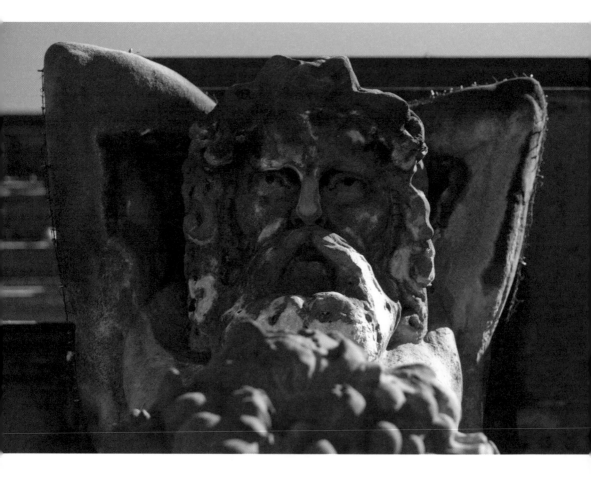

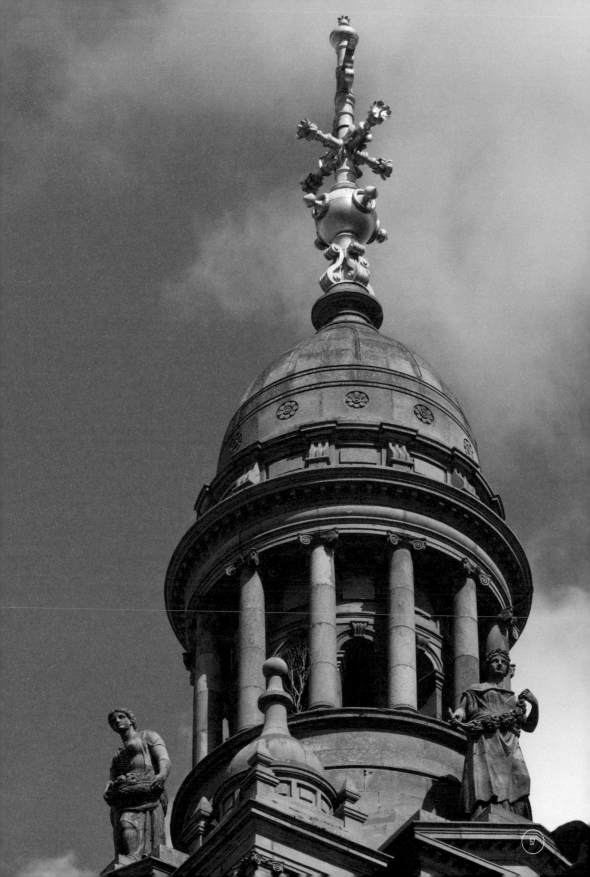

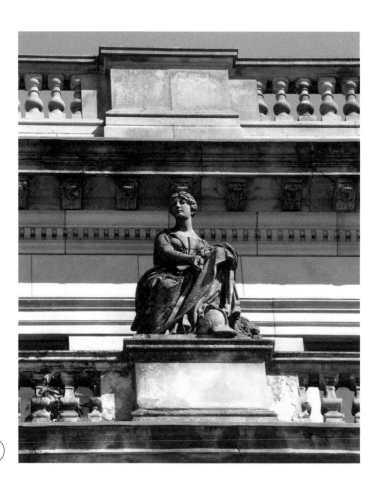

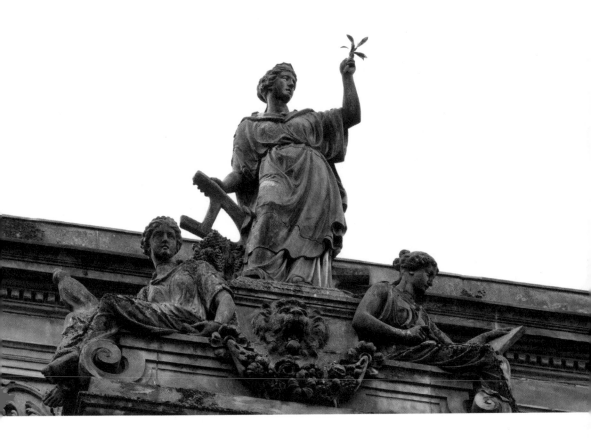

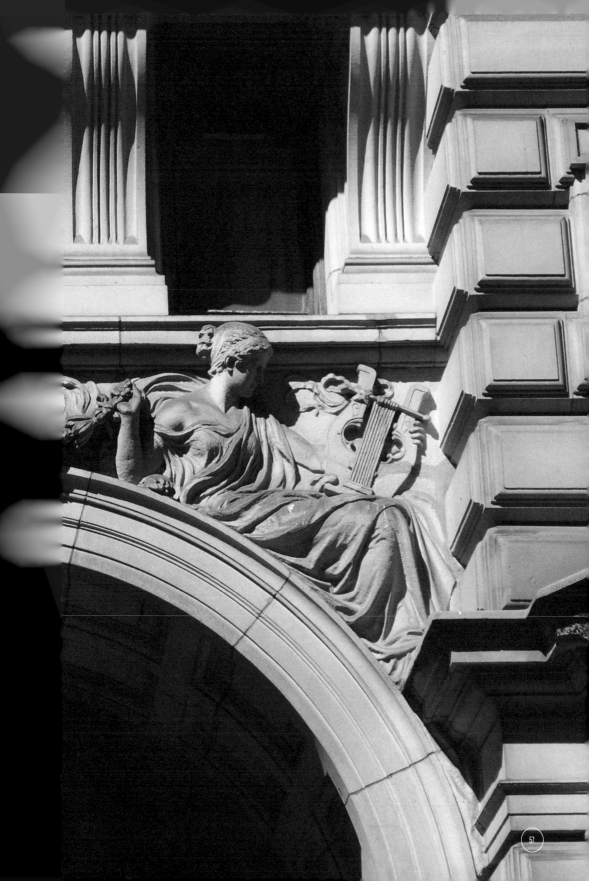

REFERENCE

1. Rear of the McLellan Galleries
145–49 Renfrew Street
Carved wreathes
and other decorative carvings

Builder: Cruikshank & Co (1856)
Rear section built: A.B. McDonald,
City Engineer (1912–13)

Built for the wealthy art collector Archibald McLellan to create a public gallery space on Sauchiehall Street, this grand edifice in the style of a Renaissance *palazzo* is markedly different to the later extension at the rear, where you can see a series of carved wreaths showing St Mungo (pictured) and the Glasgow City crest. When McLellan died his will bequeathed his gallery and vast art collection to the nation, but sadly his finances we not as splendid as the façade. In what was a controversial move at the time, the Council decided to buy the building and gallery for a nominal sum, so that McLellan's legacy could be fulfilled.

2. Albany Chambers
528–34 Sauchiehall Street
Statue of Britannia and Associated
Armorial Reliefs

Sculptor: Unknown (1896–9)

A very British theme dominates Albany Chambers, with a larger-than-life Britannia armed with a trident standing tall over a selection of shields bearing lions. The building was erected in 1897, in commemoration of Victoria's Diamond Jubilee.

3. 520 Sauchiehall Street
Allegorical Figure of Harmony,
and Colossal Bust of Beethoven

Sculptor: James Alexander Ewing (1903–4)

The building was originally designed as a piano and organ warehouse, hence the reference to musical harmony invoked by an angel with two pipes.

4. Royal Highland Fusiliers Museum
518 Sauchiehall Street
Two Seated Michelangelesque Figures

Sculptor: McGilvray & Ferris (1903–4)

Two seated figures strike poses referencing characters on the Sistine Chapel ceiling. The premises originally belonged to T. & R. Annan & Sons, fine-art dealers. Amongst other things, the son James was known for his photography skills; one of his portrait subjects was Charles Rennie Mackintosh.

5. Bank of Scotland
235 Sauchiehall Street
Two Allegorical Figures

Sculptor: Benno Schotz (1929–31)

These rather severe figures are located in niches above the main entrance of a Classicist building. The male figure on the right (pictured) stands with his arms demonstratively folded; his more forgiving female companion carries a cornucopia, which is, however, ominously empty. All in all, not a very inviting front for a bank.

6. Glasgow City
Free Church of Scotland
265 St Vincent Street

Architect: Alexander 'Greek' Thomson (1859)

The former St Vincent Street Church, west of the city centre, was completed in 1859. The constituent parts display different styles, with a typical Thomson Greek temple placed alongside an exotic clock tower. When many of Thomson's other creations were falling to ruin in the 1960s, the Glasgow Association of Spiritualists saved the church from dereliction.

7. Sovereign House
158 West Regent Street
Relief of Christ Healing the Deaf
and Dumb Man

Sculptor: Unknown (1893–5)

Above the entrance to Sovereign House is a relief depicting a scene from Mark's Gospel in which Christ heals a man of his deafness and speech impediment. It was built as the Glasgow Institute for the Deaf, but later renamed the Royal Glasgow Institute after a donation from Queen Victoria.

8. 98–104 West Regent Street
Statue of St John the Baptist
St John the Evangelist, Sun

Sculptor: J.L Cowan (1895–6)

Originally designed by the Masons as a temple and meeting room, the Blythswood building is rich in symbolism, featuring a figure likely to be John the Baptist dressed in a sheep's coat, holding a lamb, and St John the Evangelist, dressed in a toga, carrying a chalice. The building was erected at modern-day cost of approximately £1.2 million.

9. 200 St Vincent Street
St Andrew, Allegorical Figures
and Associated Decorative Carving

Sculptors: Archibald Dawson; Mortimer, Willison & Graham (1926–29; 1953)

Among the work on display here is a carving of Scotland's Patron Saint, larger-than-life and standing on board a sea-faring ship. Below him we see the morose figure of a Seafarer's Wife gazing longingly across the horizon, and opposite her a young man tightly clutching a model ship.

10. 190 St Vincent Street
Allegorical Figure of Justice

Sculptor: Unknown (1897)

Stood atop the three-storey block is a classic depiction of Justice — a female figure holding a sword in one hand and a set of scales in the other. But what is she doing on top of a commercial property? We may never know, owing to the loss of the sculptor's identity.

11. 127 St Vincent Street

Architect: John Hutcheson (1897)
Sculptor: R. A. McGilvray

This free Renaissance-style commercial building was built in 1897, and is noted for its steep Westmoreland slate roof with a red tile ridge, and of course the curved bay where the entrance is situated.

12. 105–13 St Vincent Street

Architect Frank Southorn, 1911

At the ends of the balconies of this Classical Edwardian commercial building can be found four figures, identified by the objects they have with them. Security has a beehive at her feet, Victory (pictured) has a wreath, Wisdom an open book, and Abundance has been lumbered with yet another cornucopia. It was built using a new technique of building around a steel substructure, thus allowing it to reach the maximum height permitted under the Glasgow Building Act of the time. Not quite a skyscraper though, is it?

13. 90 St Vincent Street

Architects: John A. Campbell and A. D. Hislop (1910)

The Northern Assurance Company built in 1910. It was the first in Glasgow to be built of Portland stone, and is said to be fireproof. The company shared the building with the Glasgow Imperial Union Club, who had a separate entrance at number 94. This relief over the main entrance closely resembles that of The Northern's, though lions have replaced the unicorns it was traditionally associated with, perhaps to give an increased sense of security.

14. 78 St Vincent Place

Phoenix Trophies

Sculptors: Bromsgrove Guild
of Applied Arts (1912–3)

Built above the ground floor of a giant,
seven-storey building we see three,
large phoenixes. The mythical beasts of
rebirth are shown rising out of piles of
helmets, swords, and other relics of war
— presumably an image the insurance
company who originally worked inside
felt fitting.

15. 188–94 West George Street

*Poseidon, Amphitrite and Associated
Decorative Carving*

Sculptor: Unknown (1901)

With a central bay featuring carvings of
Poseidon, his wife Amphitrite, a lighthouse,
galleons, and a pair of lively walruses, it's
not hard to guess where Britannia Life
Ltd's business interests lay. Built at the turn
of the century, it is one of the city's younger
insurance offices.

16. 169 West George Street

Architect: Robert Thomson (1891)

These nineteenth-century commercial
premises were built in 1891 for McLay,
Murray & Spens, a legal firm still in
existence today (though now occupying
different offices). A blindfolded woman
features on the front.

**17. James Sellars House
144–6 West George Street**

*Spandrel Figures and Associated
Decorative Carving*

Sculptor: William Mossman Junior
(1877–80)

This building, renamed in 1979 in honour
of the architect who designed it, was built
for the New Club in 1880. It features
two reclining female figures above the
entrance arch, one symbolising Summer,
with scythe and a sheaf of wheat, and the
other Autumn with grapes and a pitcher,
possibly casting allusions to the work
hard/play hard attitude of this gentleman's
club. Sellars is reputed to have visited the
most important clubs in London when
designing the building, to include all the
most modern improvements and make the
accommodation as luxurious as possible.

18. 100 West George Street

Sculptor: Callum Sinclair (1990)

This beautiful cat is hidden away over
the lintel of the Royal Bank of Scotland
building on West George Street. It has
been surprised in the act of reaching
down to play with the ball supporting the
pediment beneath it.

**19. 38–42 Renfield Street
117–21 West George Street**

*Apollo and Night
and Morning Allegorical Figures*

Sculptor: William Birnie Rhind (1892–4)

Apollo, standing proud on this French
Renaissance style building, is holding a lyre
and torch, and accompanied by the figures
of Night and Morning, casually reclining
by his side. The corner towers feature relief
panels of winged female figures supporting
the arms of Scotland, England, and Ireland
(with a harp, pictured). The block stands
out due to the varied and inventive nature
of its sculpture programme; critical reaction
to it, however, was mixed.

20. 34 West George Street

*Portraits Roundels, Industrial Scenes,
and Associated Decorative Carving*

Sculptor: James Young (1898–1900)

The Connal Company's building features
some of the city's most extravagant design.
From West George Street, you can see
faces from Glasgow's industrial history,
including William Dixon, original owner of
'Dixon's Blazes', whose blast furnaces would
light up the Govanhill night sky until its
closure in 1959.

**21. Merchant's House Buildings
7 West George Street**

Caryatids

Sculptor: James Young (1875–7)

A Caryatid is a term used to describe a female figure serving as a support, much like an Atlas, the male equivalent. The scantily clad figures emerge from pillars bearing various decorations, including the arms of Glasgow.

**22. 36–62 Bothwell Street
87 Wellington Street**

*Masks Representing Different
Regions of the World*

Sculptors: McGilvray & Ferris
(1891, 1898 and 1901)

This Later Renaissance-style commercial building, built in three stages, features a number of profile heads and masks representing cultural items from all over the globe. The pictured masks are of an American Indian in full headdress and a bearded man with a turban; others include a crowned female that may possibly be Europe and a pharaonic head with papyrus plants.

23. 75 Bothwell Street

Decorative Carving

Architects: Clarke and Bell (c. 1890)

This Renaissence building was owned by Barr & Higgins Ltd, a coal mining company. They went from 41 employees in 1896 to over 700 in 1923. We don't know if they ordered the construction of this magnificent building with its turbaned door guardians, but they quickly moved on to even grander premises. It was truly the golden age of steam!

**24. Mercantile Chambers
35–69 Bothwell Street**

*Mercury, Allegorical Figures of Industry,
Prudence, Prosperity and Fortune and
Associated Decorative Carving*

Sculptors; Francis Derwent Wood,
James Young, McGilvray and Ferris
(1891, 1898, 1901)

The Bothwell Street office block supports no less than five full-size figures, including another carving of Mercury. However, far from the heroic, mythological treatment he usually receives, this Mercury appears tired, forlorn, and altogether human.

**25. Former Commercial Bank of Scotland
30 Bothwell Street**

Allegorical Relief Panels

Sculptor: Gilbert Bayes (1934–5)

Made of Portland stone, these six large panels depict Justice, Wisdom, Contentment, Prudence, and Industry and Commerce (pictured). According to critical opinion, we are unlikely to see this particular kind of neoclassical commercial architecture again, as its trend subsided before the onset of the Second World War.

26. 64 Waterloo Street

*Roderick Dhu, James Fitz-James, Ellen
Douglas and Associated Decorative Carving*

Sculptor: Richard Ferris (1898–1900)

Standing atop pillars against the building's main façade are the three principle characters from Sir Walter Scott's *The Lady of the Lake*. The depiction of Rhoderick Dhu was the same one used on the bottles of 'Old Highland Whiskey' produced by original owners Wright & Greig Ltd.

**27. Royal Bank of Scotland
22–4 St. Enoch Square**

*Symbolic Figures and Associated
Decorative Carving*

Sculptor: Phyllis Archibald
and Richard Ferris (1906–7)

The four figures function as supporting pillars, and represent the fundamentals of banking — Exchange, Security, Prudence, and perhaps worryingly, Adventure. Low ceilings mean the figures are far closer to the ground than is normal in Glasgow.

28. Custom House
298–306 Clyde Street
Royal Arms of Britain

Architect: George Taylor, 1840

An article in the Glasgow Gazette was damning over about the underwhelming nature of this work, and related an anecdote in which someone balanced a tobacco pipe in the little lion's jaws. The subsequent ridicule caused such embarrassment that a new coat was ordered. It is unclear whether the replacement went ahead.

29. 74 York Street
Lions and other decorative carvings

Architect: Neil Campbell Duff (1901)

Two imposing lions sit to either side of this svelte seven story baroque commercial building. This was one of only two buildings by Duff that had ornate carvings, and he obviously got it all out of his system on this building, which also boasts a statue of St Mungo, several grotesque masks, a heraldic shield, and a bronze, Egyptian-style female head above its entrance.

30. Baltic Chambers
40–60 Wellington Street
Ornamental Details

Sculptor: William Vickers (1897–1900)

A nautical theme dominates on this old bank, standing testament to Glasgow's seafaring links. Built in 1900 from the iconic red sandstone, the sculptures feature ship's prows and sea monsters.

31. Clydeport Building
16 Robertson Street
Mythological and Historical Figure Programme

Sculptor: John Mossman, Albert Hemstock Hodge (1882–6, 1906–8)
Architect: John James Burnet

A grand personification of Father Clyde sits atop this grandiose homage to Glasgow's former mercantile supremacy, commissioned by the Clyde Navigation Trust during its height in the nineteenth century. To the left and right of his throne, we see figures representing the two hemispheres bringing their goods to the city. Other mythological statues include Demeter with a bull, whose meaning has puzzled commentators, and Amphitrite, wife of Poseidon and mother of Triton.

32. 75 Robertson Street
Decorative Carving

Architect: J.A. Campbell (1901)

75 Robertson Street was built at the turn of the century; the architect J.A. Campbell designed the building for Robert Buchanan & Co. Carting Contractors. A cherub sits in front of the bow of a ship protruding from the corner of the building.

33. 157–67 Hope Street
Putti and Mask of Fortune

Sculptor: unknown
Architect: John Archibald Campbell (1902–5)

This traditional red sandstone building, is adorned with menacing lions, some less threatening cherubs reading a book and holding a money pouch respectively, and a coat of arms bearing numerals.

34. Former Liverpool and London and Globe Insurance Building
112–18 Hope Street
Allegorical Structure, Figurative Reliefs and Associated Decorative Carving

Sculptor: James Young (attrib.) (1899–1901)

We owe the splendour of many of these buildings to the late nineteenth-century competition for dominance amongst financial institutions and this one is no exception. Amongst the rich variety of sculptural embellishment are a full-length female figure, a lion and a unicorn, a male figure holding a globe, and a winged male holding a shield decorated with a liver bird — signifying Liverpool.

35. Standard buildings
94–104 Hope Street
Atlas

Sculptor: James Young (1890)

Striding the top of the Hope Street block is a carving of Atlas, holding up the weight of a globe. At the time of building the figure was criticised, with one writer claiming Atlas was 'pretending to stagger under the weight', and that he and his 'hollow sham' of a globe would be better off in the cellar.

36. Former Scottish Temperance League Building
106–08 Hope Street
Statues of Faith, Fortitude and Temperance, Relief Medallions, Putti and Masks

Sculptor: Richard Ferris (1893–4)

Towards the south end of Hope Street we find the once popular Temperance League's former base of operations. Standing tall atop the building is an image of Temperance himself, a book in one hand, and a fitting in the other which suggests he once held something else, long since lost.

37. Former Glasgow Evening News Building
67 Hope Street
Two Seated Female Figures and Associated Decorative Carving

Sculptor: Not Known (1899–1900)

Sitting high above either side of the largely unoccupied office block are two female figures with shields, who appear to mirror each other exactly. It is unclear if they symbolize anything. Originally the home of Glasgow Evening News, we can also see a printing press and a pair of owls.

38. Atlantic Chambers
45 Hope Street (1899–1900)
Columbia, Britannia and Associated Decorative Carving

Sculptor: McGilvray & Ferris (1899–1900)

The seven-storey red sandstone building is a transatlantic affair. The building itself is an imitation of the vertical elevator building-style synonymous with Chicago. Perched on the façade are the figures of both Columbia and Britannia. Both carry shields baring their respective nation's flags.

39. Caledonian Chambers
75–95 Union Street
Atlas

Sculptor: Albert Hemstock Lodge (1901–3)

This particular Atlas figure supports one of the projecting first-floor balconies on a large seven-storey commercial building that was designed for the Caledonian Railway Company at the turn of the century. The figures are naked and crouching because this was seen to be expressive of their role as load-bearings, reminding us why we don't miss Victorian working conditions. The right atlas was heartlessly maimed by the insertion of a scaffold pole in spring 2000.

40. Second Caledonian Railway Bridge
Near Central Station
Engineer: Donald A. Matheson & Sir John Wolfe Barry

The Caledonian Railway Company was keen to develop, and in 1905 the 'New Clyde Viaduct' as it was originally known, was opened alongside the first bridge, giving a total of 13 tracks into Central Station. At one time it was the widest railway-over-river-bridge in the country. Before opening, it was load-tested with 19 locomotives.

41. 1–11 Renfield Street

Quadriga and Winter allegorical figures

Sculptor: William Birnie Rhind (attrib.)
(1896–9)

This retail block on Renfield Street is
adorned by charming yellow sandstone
figures. The centrepiece is a Roman chariot,
known as a quadriga. The walls of the dome
feature a set of female figures symbolising
Summer and Winter. To faithfully
represent the Scottish climate, we have
chosen to include only the Winter figure.

42. 42–50 Gordon Street

Relief of Athena

Sculptor: unknown (1886)

Athena is shown here in full garb, wearing
a helmet, an armoured breastplate, and
a classical tunic, as well as holding a spear
and a daunting miniature fortress. She is
accompanied by an owl, a snake, and a tree;
the owl and fortress are especially relevant
as the building was originally built to house
the Royal Exchange Assurance Company.

43. Starbucks
58 West Nile Street

Decorative Carving

Architect: James Boucher (1875)

This listed building features a Starbucks
on the ground floor and winged mythical
creatures sitting either side of the second-
floor balcony, judging you for getting
whipped cream on your latte.

44. Athenaeum Building
8 Nelson Mandela Place

Portrait Statues and Allegorical Figure Groups

Sculptor: John Mossman (1886–8)

Among the figures portrayed along the
top of the former Athenaeum Building are
English Baroque composer Henry Purcell,
and the English portrait painter Sir Joshua
Reynolds. The building was inaugurated by
Charles Dickens in 1847.

45. The Library of Royal Faculty
of Procurators
68 West George Street
12 Nelson Mandela Place

Busts of Law Lords

Sculptor: A. Handyside Ritchie
Architect: Charles Wilson
Built: 1854

The keystones of windows and doors in
ground floor are ornamented with heads
of many of the most distinguished
Scottish law lords. In the front, to
West Nile Street, beginning at the north
window, are the carved likenesses of
Lords Erskine, Mansfield, and Brougham;
in West George Street, of Lord Blair, John
Erskine, Lords Stair, Kaimes, and Forbes;
in St. George's Place are James Reddie
and Professor Miller (both of Glasgow),
then Lords Moncrieff, Jeffrey, Cockburn,
and Rutherford. Over the principal door
is placed the head of Lord Jeffrey, and over
the other that of Lord Stair, as if to remind
entrants of the penetration and sagacity,
the acumen and erudition, as well as the
probity necessary, to master the difficult
science of jurisprudence.

46. Gallery of Modern Art
Royal Exchange Square

Decorative Carving

Architect: David Hamilton
Builder: John Smith & Son

The building of the Gallery of Modern
Art (GoMA) — the most visited modern
art gallery in Scotland — was originally a
country home. It was built in 1775 for one
of the city's most wealthy "Tobacco Lords",
William Cunninghame of Lainshaw,
who made his money overseas during the
American War for Independence.

47. Glasgow Stock Exchange
155–59 Buchanan Street
63–69 Nelson Mandela Place

Statue of St Andrew and decorative carving

Architects: John Burnet 1875–1877
Sir John James Burnet 1894–1898
Sculptors: J & G Mossman

Inspired by the Royal Courts of Justice,
this building is in the Venetian Gothic
style. The Glasgow Stock Exchange was
founded in 1844 and was operating from
this building until 1973, when it merged
with the London Stock Exchange. See if
you can spot the terrible restoration work
applied to one of the statues on the corner
of the building (p.91).

48. House of Fraser Department Store
45 Buchanan Street
134–56 Argyle Street
Winged Female Figures and Imperial Arms;
Pair of Atlantes

Sculptors: William Vickers
(1884–5; c. 1899–1903)
Architects: Campbell Douglas & Sellars;
Horatio Kelson Bromhead

One of the largest warehouse buildings of
its time, the Renaissance-style House of
Fraser on Argyle Street is ably supported
by a pair of Atlantes, identical in design,
and known as 'Stewart' and 'McDonald'
in popular parlance, after the wholesale
drapery merchants who commissioned the
warehouse. On the Buchanan Street side,
a decorative pedestal supports the imperial
arms, to both sides of which we see
allegorical female figures representing
Art and Industry, and carrying a palette
and brushes and a distaff, respectively.

49. Commercial Building
91 Buchanan Street
Relief Panels with Putti
and Associated Decorative Carving

Sculptor: Unknown (1896–7)

Just above the first floor we see a number
of podgy male youngsters playing amongst
an abundance of garlands and fruit. The
building was originally opened as a 'tea
and luncheon' room by one Catherine
Cranston, who amongst other things
was a leading advocate of temperance.

50. Commercial Building
60–2 Buchanan Street
Allegorical Figures

Sculptor: unknown (1894–6)

The fourth storey of this *fin de siècle*
Baroque building features a pair of free-
standing allegorical female figures: *Justice*
on the left, holding a sword and a pair of
scales; *Truth* on the right, holding a mirror
and having removed a blindfold from her
eyes. The design was influenced by the
extremely narrow site it had to be built on.

51. Former Glasgow Herald Building
63–9 Buchanan Street
Narrative Relief Panels and Associated
Decorative Carving

Sculptor: Charles Grassby (1879–80)

Highly fitting for the headquarters of
a major Scottish newspaper, the four
vertical relief panels on this building depict
figures performing various activities related
to the production of a newspaper: carrying
a bed of type, working a press, conducting
an interview, and, apparently, weeping. The
building was erected as a monument to the
flourishing and wealthy Glasgow Herald at
the end of the nineteenth century.

52. Argyll Chambers
28–32 Buchanan Street
Pair of Allegorical Female Figures

Sculptor: James M. Sheriff (attrib.)
(1903–4)

The two personifications on this building
have been identified as *Industry* on the left
and *Commerce* on the right. The building's
owner in 1894, the wealthy tea importer
Stuart Cranston, is credited with planting
the roots of our present-day addiction
to tea.

53. Commercial Bank of Scotland
4–16 Gordon Street
113 Buchanan Street
Narrative and Allegorical Reliefs of Children
and Associated Decorative Carving

Sculptors: John Thomas, Alexander
Handyside Ritchie (1853–7)
Architect: David Rhind (1854–7)

Built as the head office of the now-
defunct Commercial Bank of Scotland,
this building incorporates a pair of reliefs
celebrating banking in all its glory; but
unconventionally, it is infant cherubs
who are operating various machinery
and making coins and bank notes.
The decorative masks looking out over
the city, however, are those of adult men.
This admirable monument to the strength
of commerce cost about £9.7 million in
today's money to erect, plus a further
£130,000 for sculptural ornamentation.

54. 30 St Vincent Place

Allegorical Figures, and Associated Carving

Sculptors: John Mossman,
William Mossman Junior
and Charles Grassby (1871–4)

A homage to the world of commerce, the grand female figures standing over their male counterparts represent Industry and Trade. Below these, two additional figures represent Sewing and Reaping. At the time, the building's overly-lavish design was criticized as illogical, and lacking in purpose.

55. 14 St Vincent Place

Decorated Masks and Associated Carving

Sculptors: H.H. Martyn and Co (1905–7)

Originally built for the Anchor Line Steamship Company, this imposing Edwardian-Style building is covered in maritime references, including a large mask of Neptune accompanied by sea monsters, and a pair of lovingly-crafted Mercury masks.

56. 2 St Vincent Place

Atlantes, and Associated Decorative Carving

Sculptor: William Mossman Junior
(1867–70)

In the doorway of the former Bank of Scotland we see two figures straining under the weight of the building. Heads bowed and muscles bulging, these two Atlantes were among the most celebrated works of their day.

57. City Chambers
80 George Square

*Allegorical and Decorative
Sculpture Programme*

Sculptors: Numerous (1883–88)
Architect: William Young

Glasgow City Chambers was built in direct competition with Manchester's own new town hall, and is easily the grandest of all Glasgow's Victorian architecture. The grounds feature many major statues and numerous carvings, together constituting the single most extensive sculpture programme in the city. Defeating 125 competing designs, the architect William Young won the commission in 1881. The laying of the foundation stone in 1883 was marked by a public holiday, which led to the largest recorded gathering in Glasgow — with an estimated 600,000 people witnessing the event. The building was inaugurated during Queen Victoria's 1888 visit to Glasgow, a year before City Chambers officially opened to the public.

MERCHANT CITY

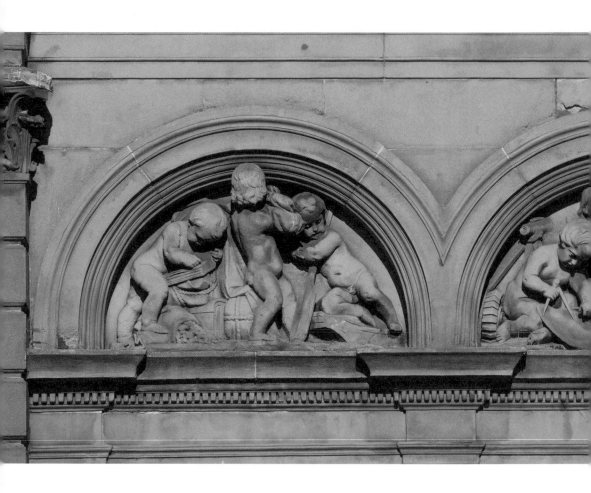

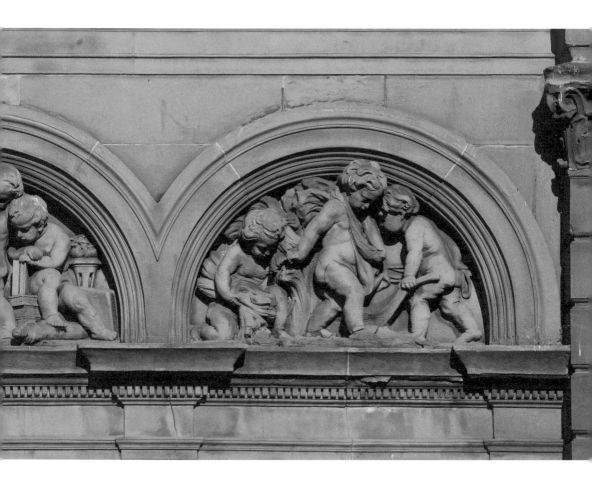

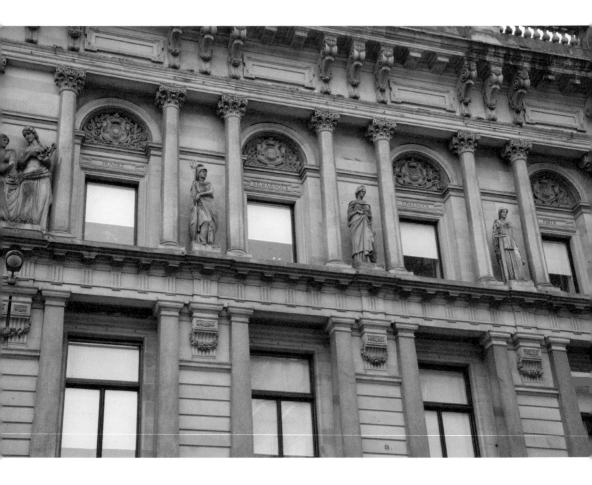

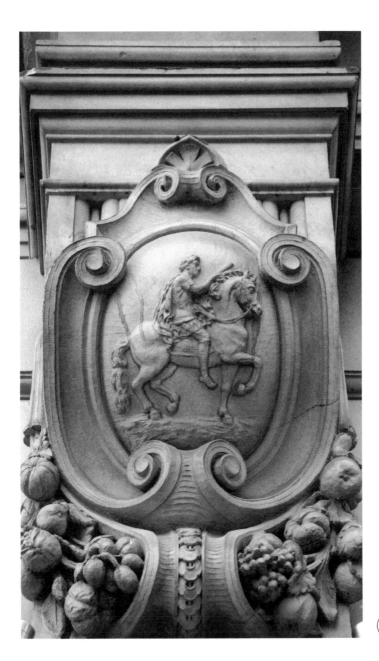

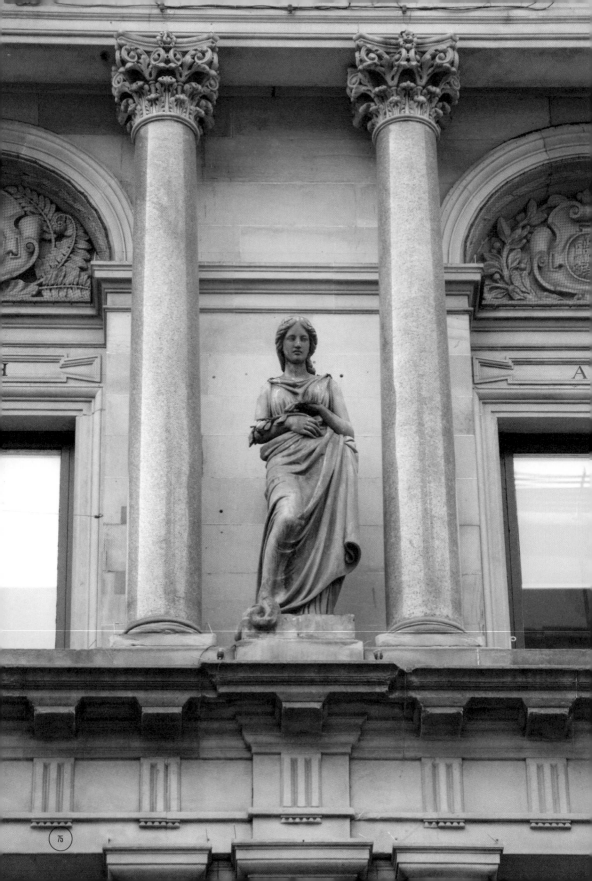

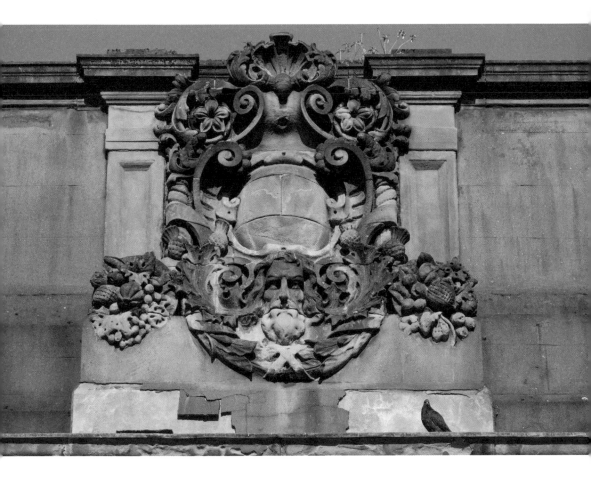

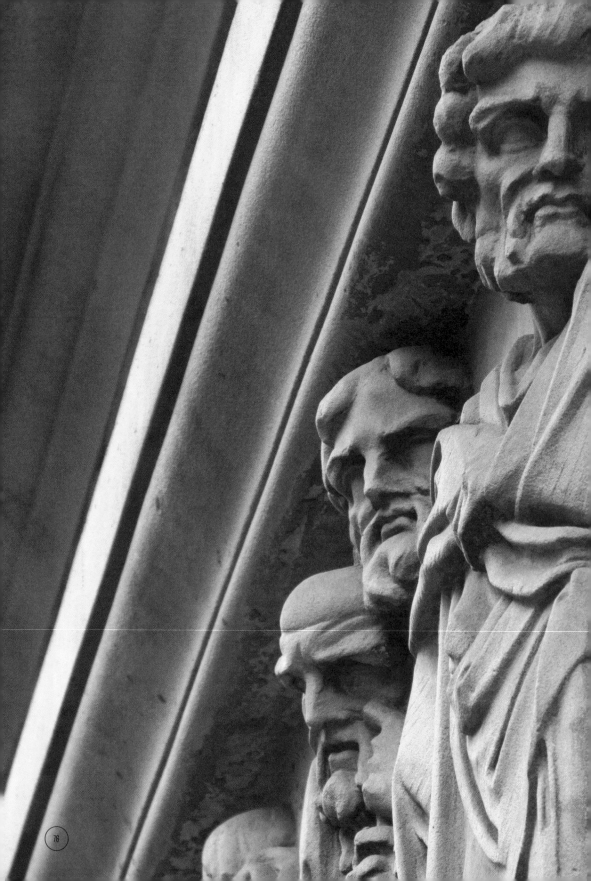

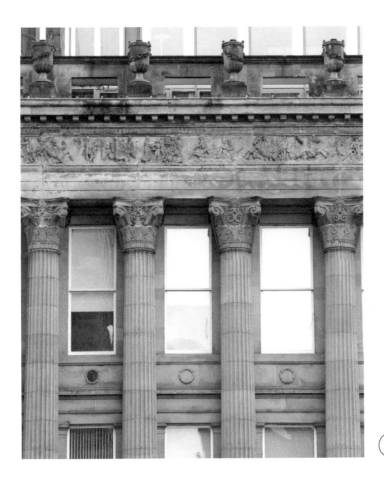

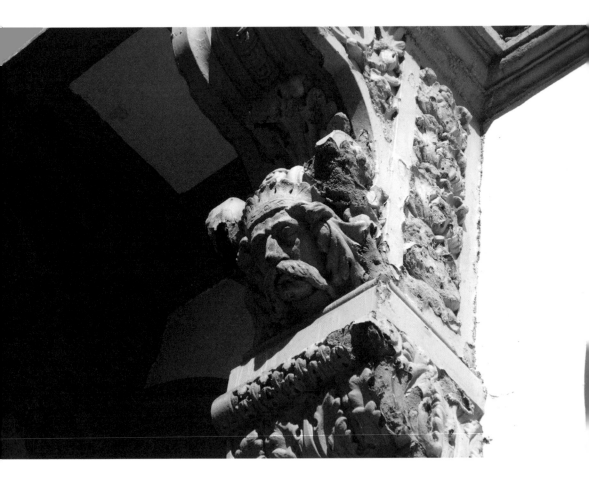

Look up Glasgow!

Colin Begg

Never mind the rest of Northern Europe,
there is nothing like you in all the world.
Your ships plied queer coasts just to check
and reported safe to your quaysides.

Look up Glasgow!
loftier are your caryatids, your atlantes
than the window cranes of Amsterdam,
the lead-strafed lintels of Berlin,
the sleepy dormers of Paris,
the Hanseatic gables.

Look up Glasgow!
your merchants have done their pillaging
on fair winds (but not fair trade)
and bought your gilded ships
and rooftop globes.

Look up Glasgow!
be glad that the grabbing is over
and the slaves are freed.
But, architects of Glasgow —
to what honour would you sculpt today?

Look up Glasgow!
call centres, retail parks, giant horses,
are such feeble phoenixes.
With what phatic exaltations
shall we chisel our city centre now
to feed the algae of tomorrow?

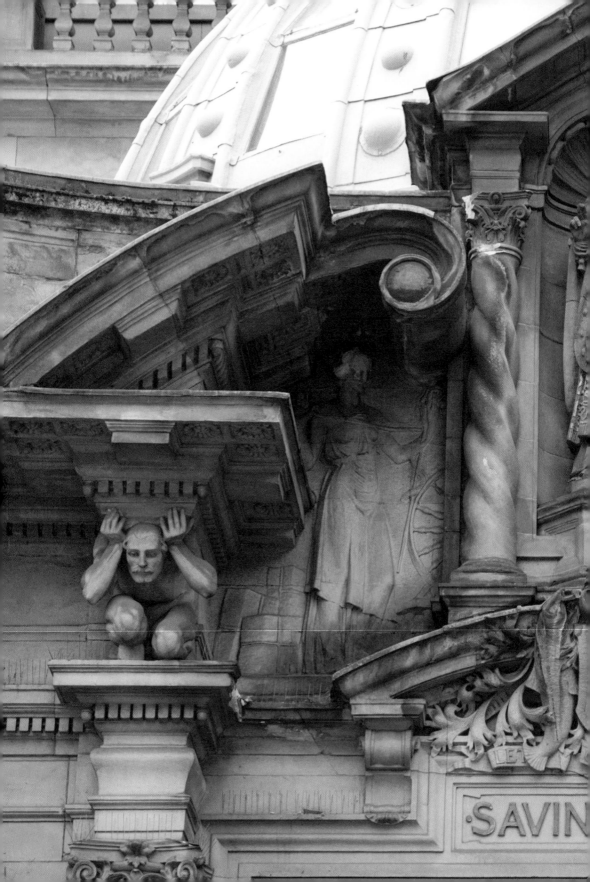

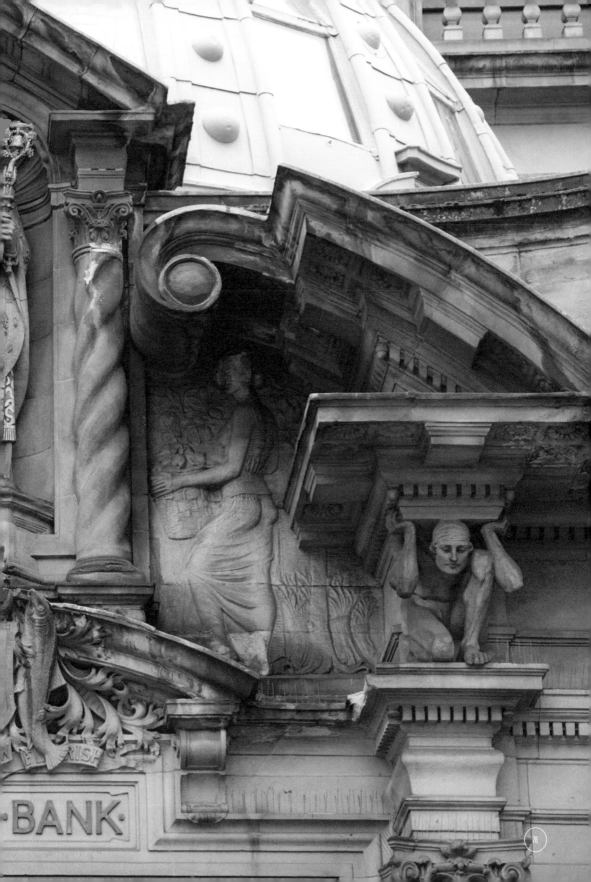

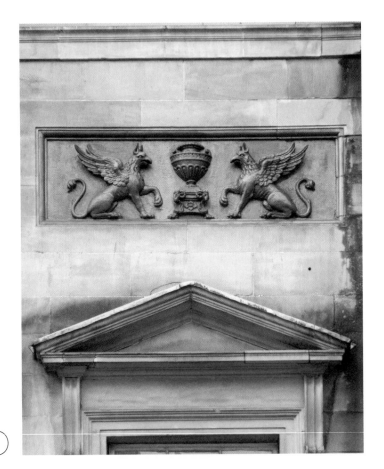

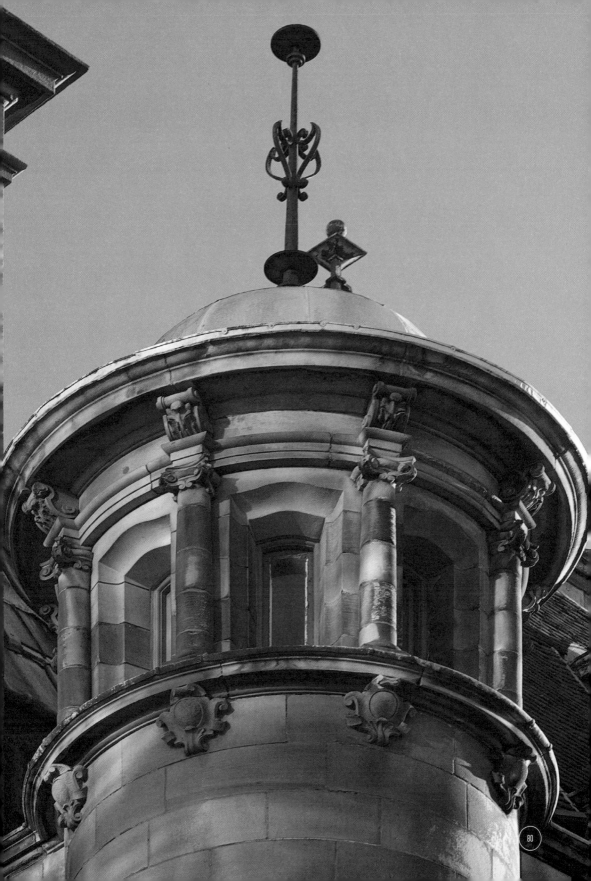

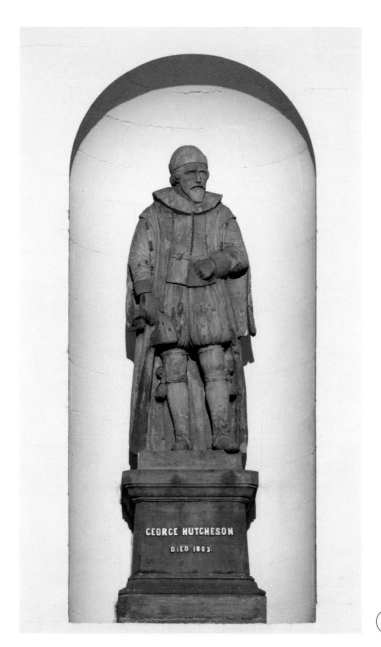

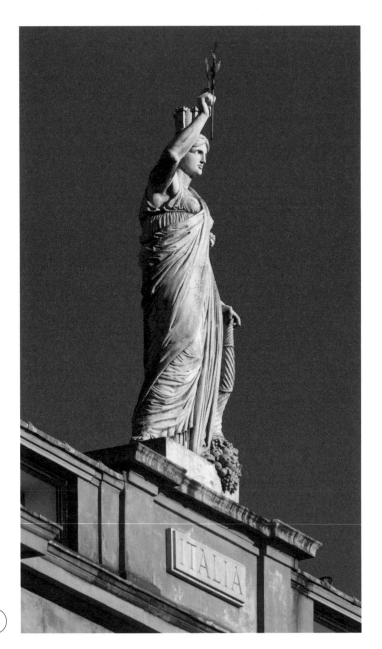

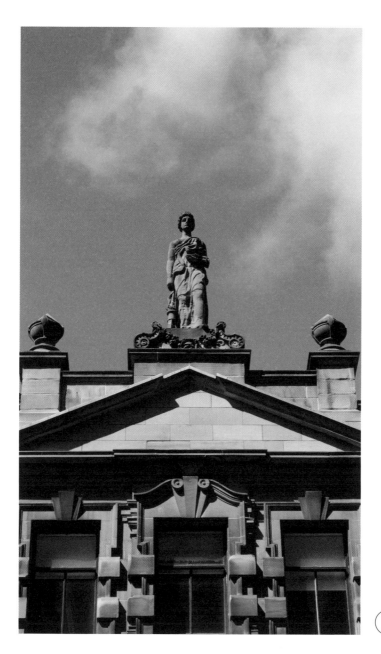

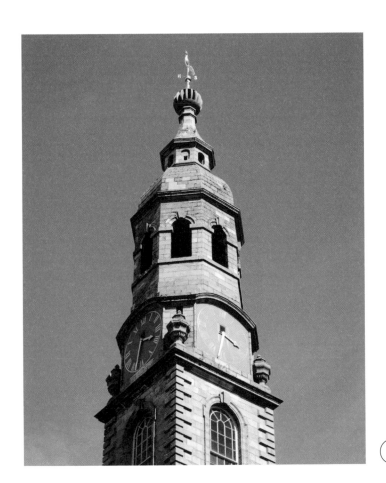

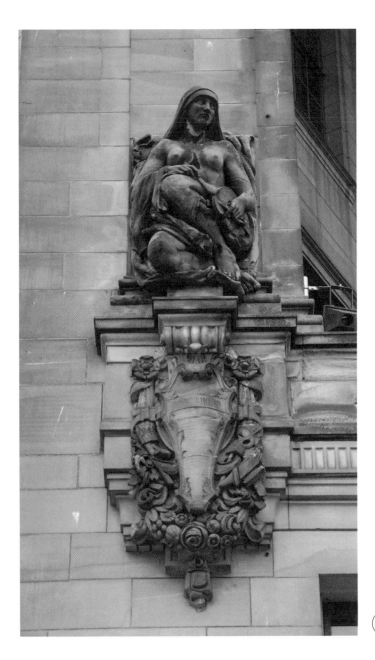

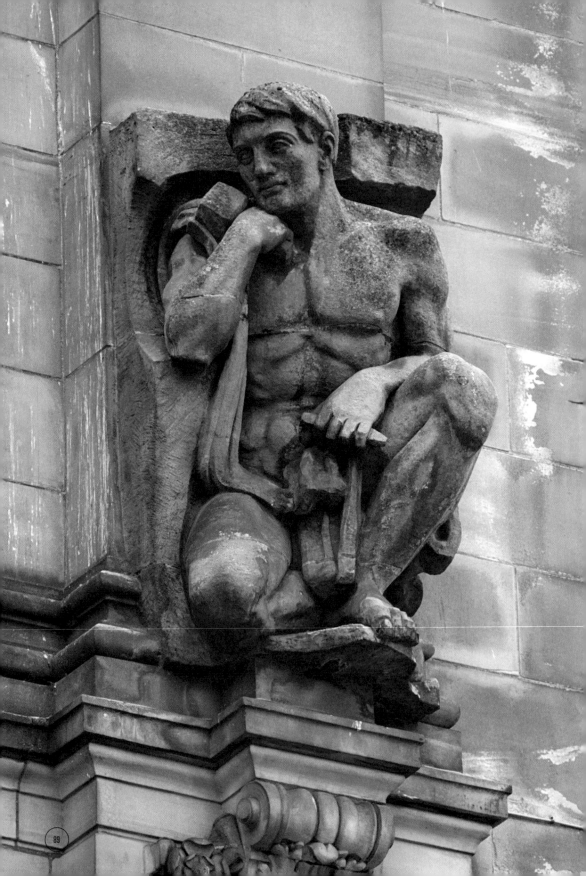

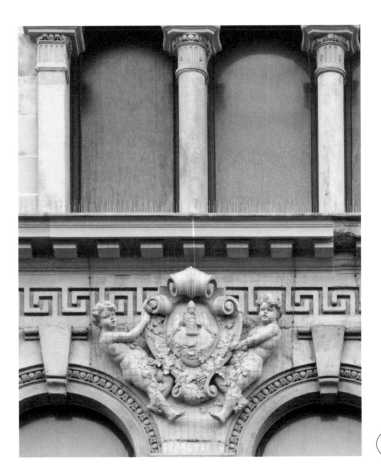

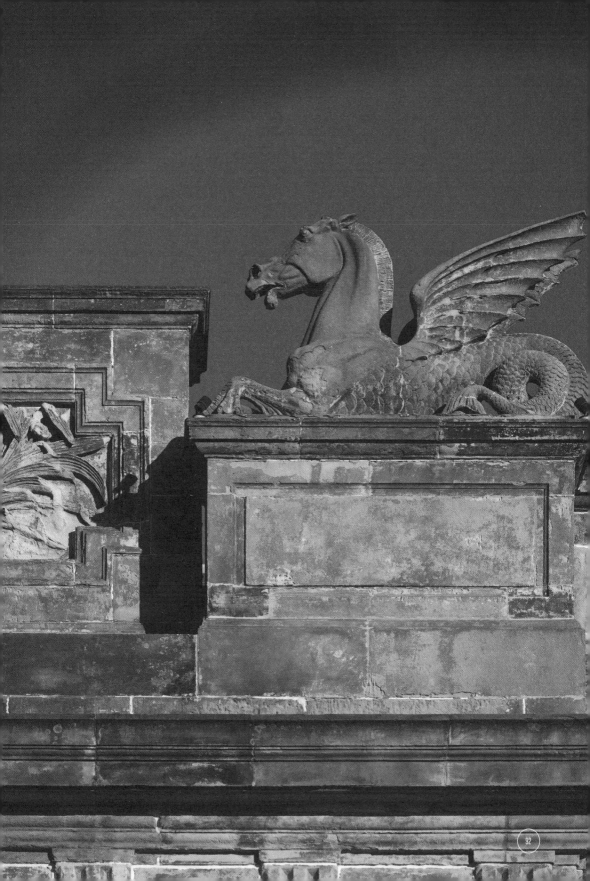

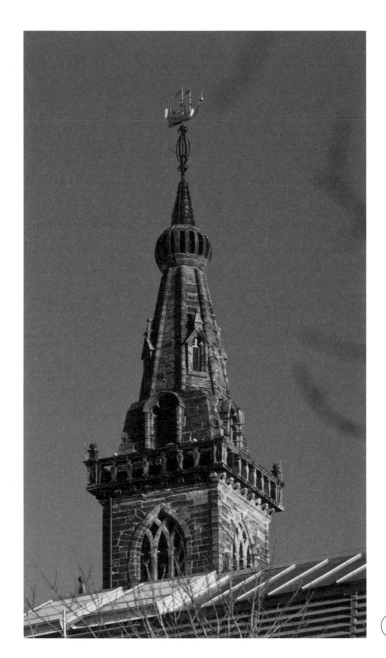

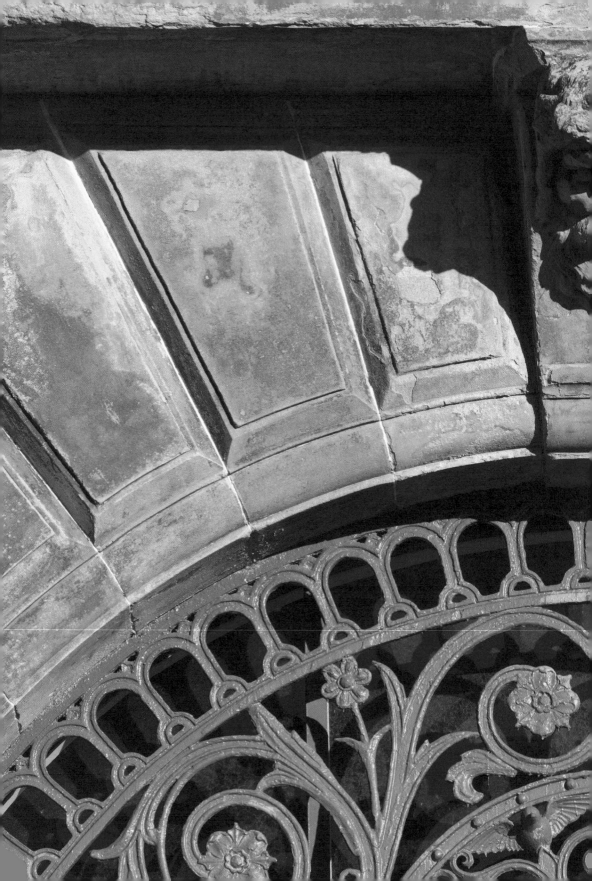

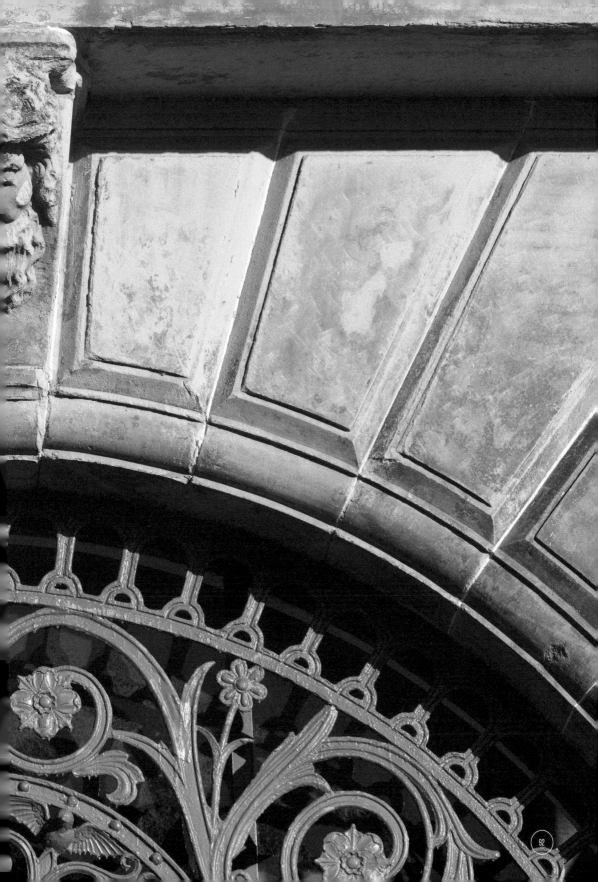

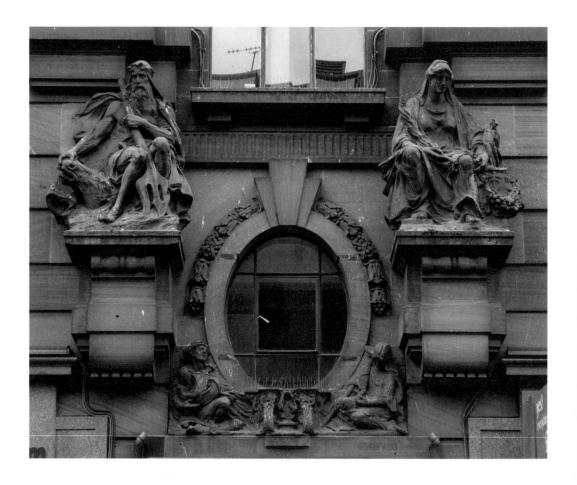

REFERENCE

75. Corinthian
191 Ingram Street
Allegorical Statues, Narrative Tympana
and Associated Decorative Carving

Sculptor: James Salmon Senior and
John Burnet (1841–3, 1853–4, 1876–9)

The Corinthian building has a rich history,
having been used as a bank, a high court,
and currently houses a bar and restaurant.
Allegorical female figures on the façade
represent various high ideals, including
Navigation and Commerce, Britannia,
Wealth and Glasgow. The rear of the
building also includes a lavish decorative
programme.

76. Former City and County Buildings
40–50 Wilson Street
'Trial by Jury' Narrative Frieze

Sculptor: Walter Buchan (1842–4)

A Greek Revival construction that dates
from 1842, this building was intended to
bring together a number of council and
law enforcement institutions, explaining
the dramatic depiction of a man in chains,
a murder victim, a mourning woman and
various court officials.

77. Former Offices Of The Glasgow
Gas Light Company
42 Virginia Street

Architects: R. G. Melvin and W. Leiper

Originally built in 1867–70 as a warehouse
for the Glasgow Gas Light Company,
a pair of crowned male heads with excellent
moustaches peer down over the entrance
of this listed building.

78. Former Trustee Savings Bank
177 Ingram Street
St Mungo, Atlantes, Allegorical Figures
and Related Decorative Carving

Sculptors: George Frampton (modeler)
and William Shirreffs (carver) (1894–9)

This striking building, formerly a savings
bank but now used by the Jigsaw chain
is an interpretation of the Roman
Baroque style and features a pair of
Atlantes one sporting a fetching moustache
worthy of Movember. Additional features
are a coat of arms bearing the city's motto,
'Let Glasgow Flourish', below a majestic
statue of St Mungo.

79. Trades House
85–91 Glassford Street
Armorial Group and Griffin Panels

Sculptor: unknown (1791–4)

The Trades House constitutes one of the
four major buildings designed by the Adam
brothers for Glasgow in the 1790s; it is the
only one to have survived completely intact.
Adorned by panels showing griffins on
either side of a central urn, it also features
an armorial group.

80. Former National Bank of Scotland
190 Trongate

Architect: Thomas Purves Marwick
Sculptor: William Birnie Rhind
Builders: Muir and Son, Glasgow

Built in 1903 for £9,827, this mixed
Renaissance-style building went £400
over budget due to the decision to use
Plean rather than Giffnock stone.

81. Hutchesons' Hall
158 Ingram Street
Statues of George and Thomas Hutcheson
and Clock Tower Spire

Sculptor: James Colquhoun
(statues c.1649; building 1802–5)

The Hutchesons were landowners, money-
lenders and notaries, and are considered
general benefactors of Glasgow. Both
brothers unfortunately died before the
completion of the Hutchesons' Hospital,
which they founded. George Hutcheson's
date of death includes an unfortunate
blunder, with the last two digits having
been accidentally reversed.

82. Italian Centre
7 John Street
Italia Statue

Sculptor: Alexander Stoddart (1988–90)

This striking neo-Classical figure of a
personified Italy bears a number of features
associated with Italian culture, amongst
them the palm branch in the figure's raised
right hand and the inverted cornucopia in
her left hand. The helmet she wears further
recalls classical antiquity. It was designed
to acknowledge the historical influence of
Italian artisans on the Merchant City.

83. Department for Environmental Health
23–25 Montrose Street
Hygieia

Sculptor: William Kellock Brown (1894–7)

Fittingly installed atop the loft of the Department for Environmental Health is a statue of Hygieia, the Greek Goddess of Medicine and Sanitation. A pair of snakes twist their way round her body to drink from a bowl in her left hand. The statue has been badly weathered and requires restoration.

84. Merchant Square and Old Fruitmarket
71 Albion Street

Architect: John Carrick (1886)

Over the Bell Street entrance to Merchant Square is a mask of Athena, the grey-eyed goddess of the arts (not pictured). Further up Candleriggs, we can see an enormous sandstone sculpture of a bowl of fruit, sitting on top of the Old Fruitmarket, designed in 1886 by John Carrick.

85. Tron Theatre
63 Trongate
Cherub and Various Decorative Sculpture

Sculptor: Kenny Hunter (cherub) (1997–9)

The psychedelic collection of buildings and sculpture surrounding the Tron Theatre includes the Tron Steeple, dating from the 1590s, as well as a cherub and skull forming part of a 1990s redesign commissioned by Visual Arts Projects. A 'tron' is the beam with which trading goods were officially weighed on entering the city walls.

86. Glasgow City Council Departments of Architecture and Related Services
18–58 Albion Street
20–46 Trongate
Pediment Group and Associated Decorative Carving

Sculptors: Holmes & Jackson (c.1901–5)
Architects: Thomson & Sandilands

This red sandstone block is a combination not only of tenement and warehouse, but also of the Edwardian and Baroque styles. It was erected as part of an extensive redevelopment of the area, and features female figures of Law and Justice above the Albion Street entrance, reclining against a cross of St George.

87. Fraser Suites
1–19 Albion Street

Architect: J. T. Rochead (1855)

Built in 1855 in the Scottish Baronial style for the City of Glasgow Bank, this imposing building was by J. T. Rochead, who also designed the Wallace monument in Stirling. Sadly the bank was in worse shape than its building, and in 1878 it collapsed under £6m of debt due to fraud, embezzlement and false book-keeping — which is roughly £7,112,000,000 in today's money. While retaining the stunning Victorian façade, it has now been completely renovated into flats.

88. St Andrew's in the Square
1 St Andrew's Street

Architect: Allan Dreghorn (1754)

Formerly the church of St Andrew's in the Square, this building dates from 1754 and is widely regarded as one of the finest classical churches in Britain. It was designed by the architect Allan Dreghorn, based on James Gibb's famous St Martins-in-the-Fields in London. It has now been transformed into an exciting new centre for performing arts.

89. Mercat Building
15–23 London Road
Six Allegorical Figures and Associated Decorative Carving

Sculptors: Benno Schotz, Archibald Dawson and Alexander Proudfoot (c.1925–8)
Carvers: Holmes & Jackson
Architect: A. Graham Henderson

This building, located next to the Mercat Cross, is designed on a trapezoid plan, with each of the three main façades featuring a pair of figures — all by different sculptors. The north-east corner of the Trongate was considered to be in need of some architectural streamlining, as a result of which the Mercat Building was planned and designed.

90. Britannia Music Hall/'Panopticon'
49 High Street

Architect: Thomas Gildard
and Robert MacFarlane (1857)

City Architect Thomas Gildard and his colleague Robert H. M. MacFarlane received a commission to find a new use for an old warehouse building on Glasgow's Trongate; a tough project for a street which in 1857 was described by the North British Daily Mail as "one eighth of a mile of iniquity with over 200 shebeens [illegal drinking houses] and 130 brothels". The Trongate of 1857 was the domain of the poor and the working classes, so the two architects decided to convert the warehouse into a music hall.

Hugely popular for over a century, The Panopticon hosted acts as diverse as Mademoiselle Paula, the Reptile Conqueror, who would allow snakes to wrap around her body and played with crocodiles, and the first ever performance by Arthur Stanley Jefferson, one half of Laurel and Hardy.

91. Tolbooth Steeple
Glasgow Cross

Architect: John Boyd (1625–7)

Until 1921, the Tolbooth Steeple was still part of a larger building. The steeple itself dates from 1625-7 and was built together with the original Tolbooth which housed the Town Clerk's office, the council chamber and the city jail. The building was demolished in 1921, leaving the steeple isolated where it remains to this day.

92. The Briggait
64–74 Clyde Street
Sea Horses and Associated Decorative Carving

Sculptor: unknown (1873)

The term 'sea horse' is taken somewhat literally on this building, which features hippocampus; the mythological beasts with horse torsos, fish tails, and what seem to be dragon wings. These creatures were erected in 1873, and sit above a portrait of Queen Victoria. The building also features more subdued elements like bearded male masks and ornamental roundels, and was originally designed as a fish market.

93. 173–187 Trongate
Neptune and Ceres

Sculptor: unknown (1925)

Neptune and Ceres on the front of this six-storey Edwardian Classical-style block symbolise trade and commerce. Neptune, with a trident, holds on to a sea horse; Ceres holds a corn-stalk and is accompanied by a miniature Mercury. This rich sculpture programme on an otherwise unadorned and austere building has puzzled many.

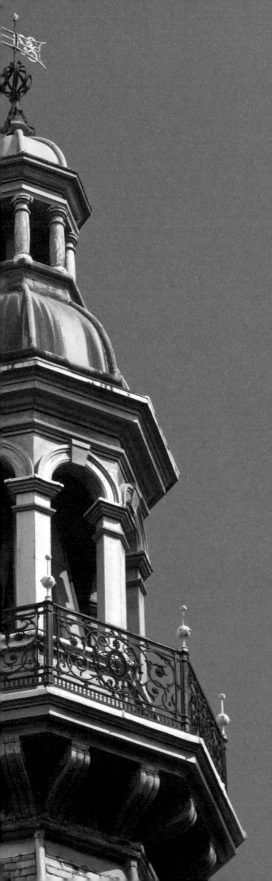

LOOK UP GLASGOW
CHARING CROSS

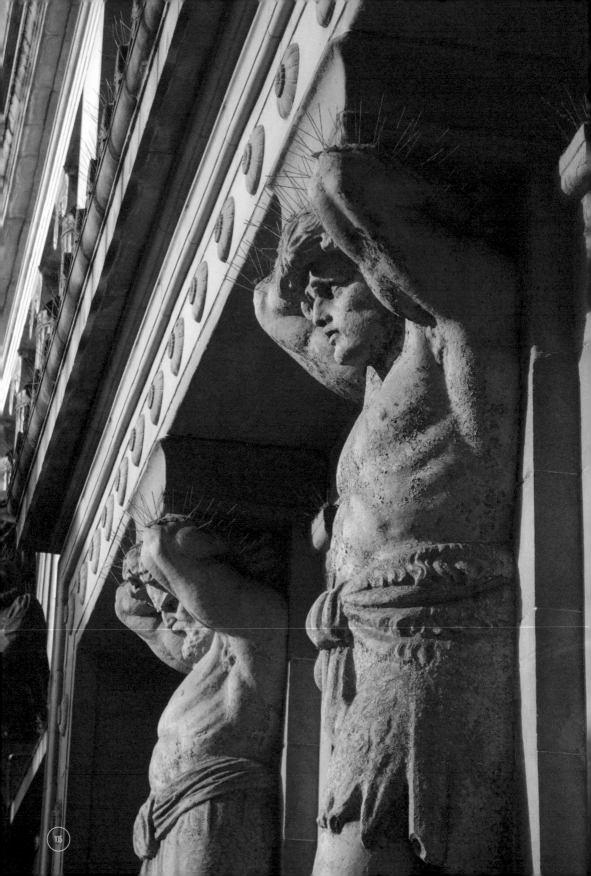

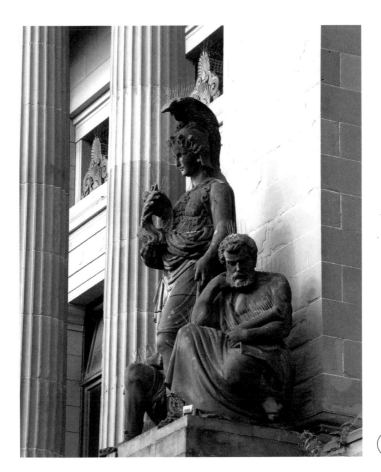

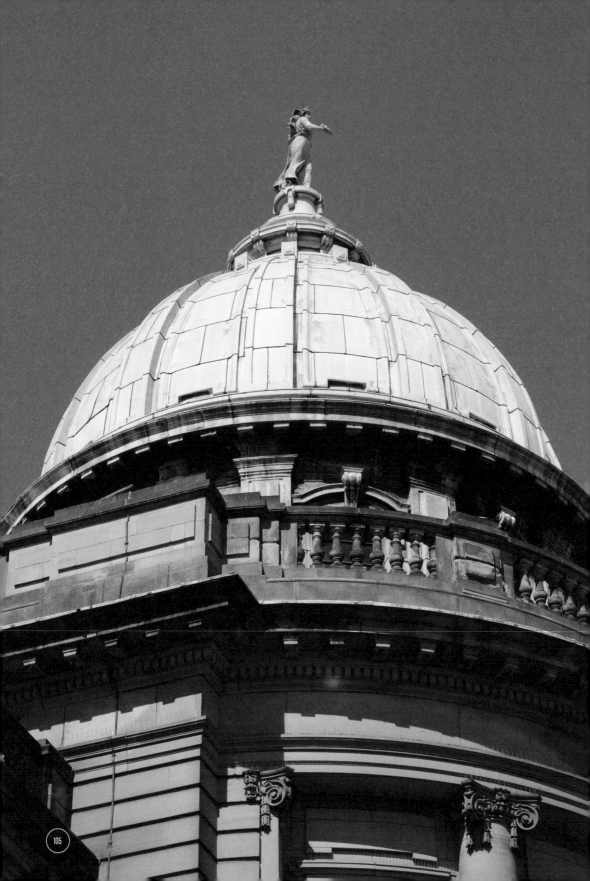

The Cleidin is a Civilisin Mission

Sophie Cooke

Dossed for some place ense — yon Grecian chiffon
can no gainstaund oor snell an blashie wather —
thae hie fowk on oor biggins aye war quarrelled oot'n Scotland:

it wis a faur ben ploy, tae stell expansion
wi bairns, lang-heidit men an dochtie caryatids:
bowsome bodies help tae humanise an Empire's architecture.

Sicna slicht: no tae feel the wecht we cairy,
an that we're stickit; no tae leuk at whit's aneath or
leuk wi unseein eyes, douce white, wyteless plunkers;

receive the peyment — grapes, corn, televisions —
like it war a seilie accident o Naitur.
We aye uphaud hame's structure, a cause o it's a shelter,

but scug an airn will that it wadna mak a god oot o a greedy principle,
an feel wir herts like ammonites beat in the stane whaur builders birsed thaim.

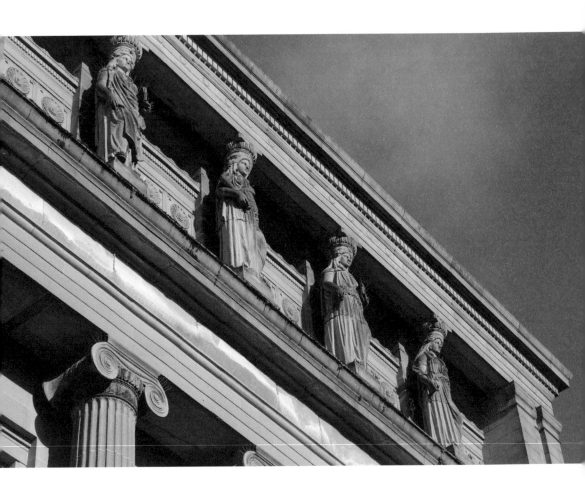

The Clothing is a Civilising Mission

Sophie Cooke

Dressed for somewhere else — that Grecian chiffon
can not withstand our sharp and rainy weather —
those high folk on our buildings were, all the same, quarried out of Scotland:

it was a popular trick, to prop expansion
with children, shrewd men and saucy caryatids:
obedient bodies help to humanise an Empire's architecture.

The art's like this: not to feel the weight we carry,
and that we're stuck here; not to look at what's beneath or
look with unseeing eyes, sweet innocent white marbles;

receive the payment — grapes, corn, televisions —
as if it were a happy accident of Nature.
We still hold up home's structure, because it is a shelter,

but hide an iron wish that it wouldn't make a god out of a greedy principle,
and feel our hearts like ammonites beat in the stone where builders pressed them.

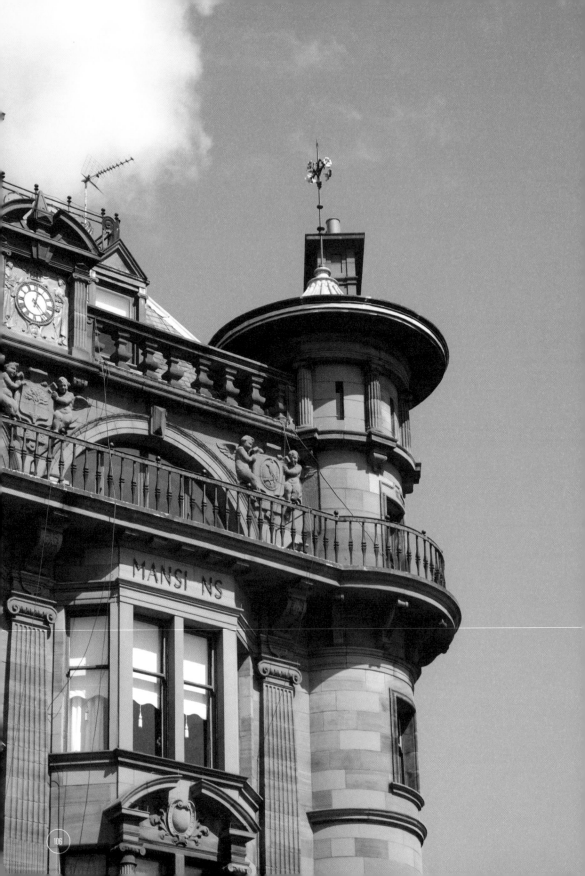

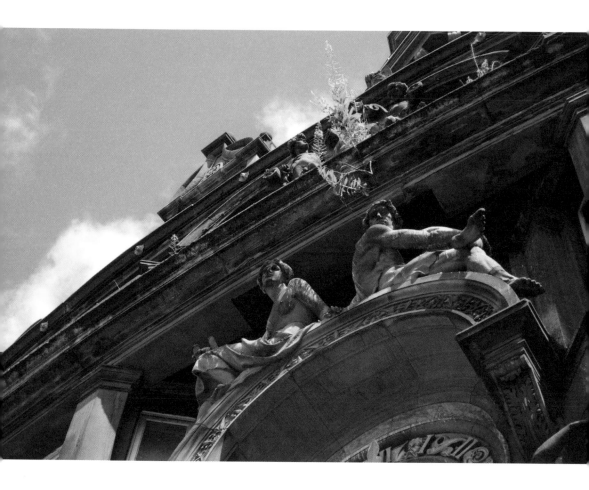

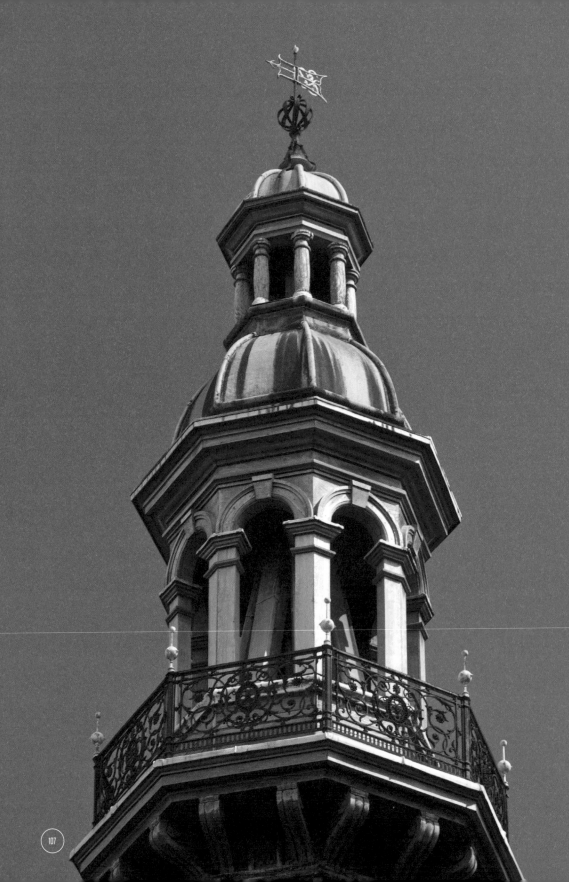

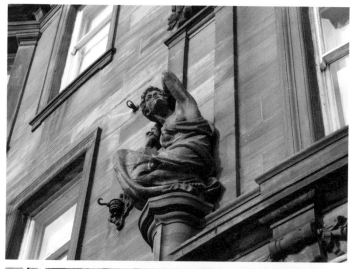

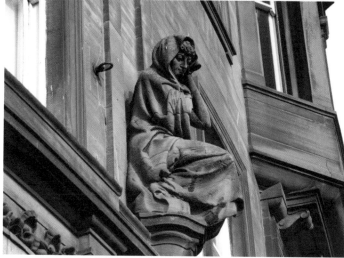

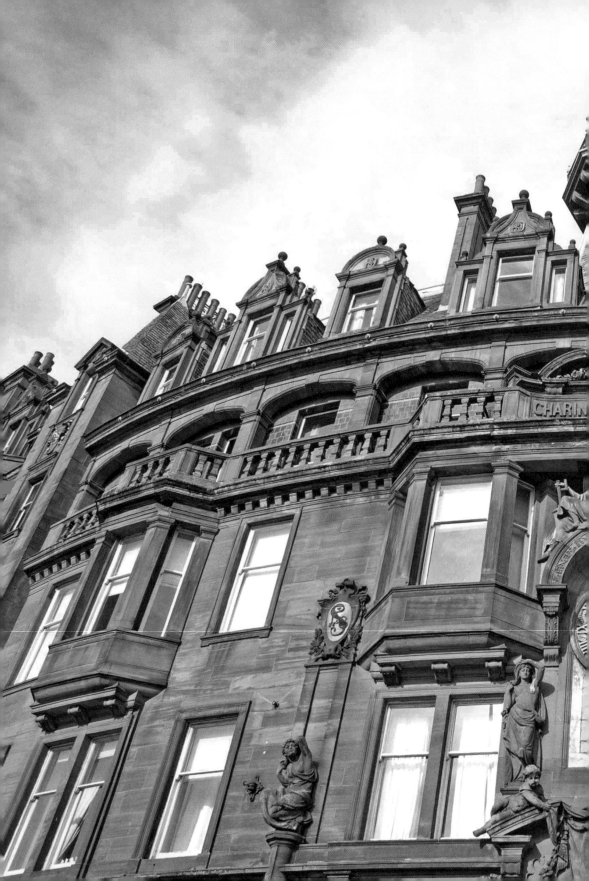

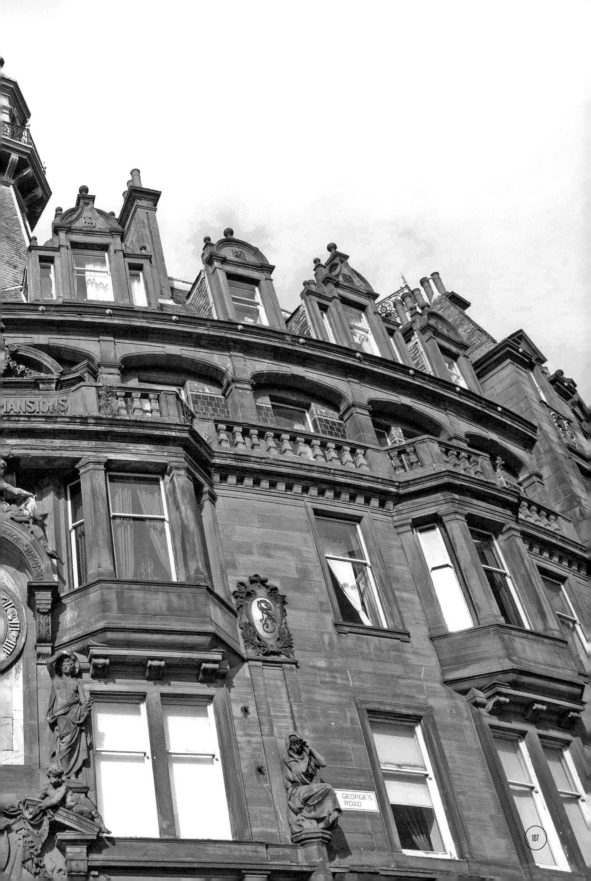

MANSIONS

GEORGE'S ROAD

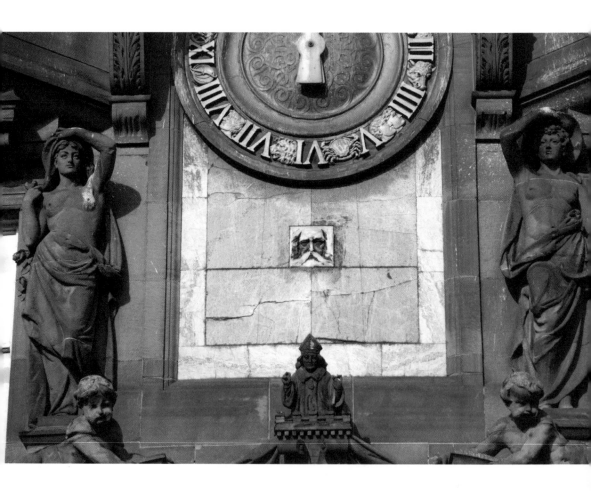

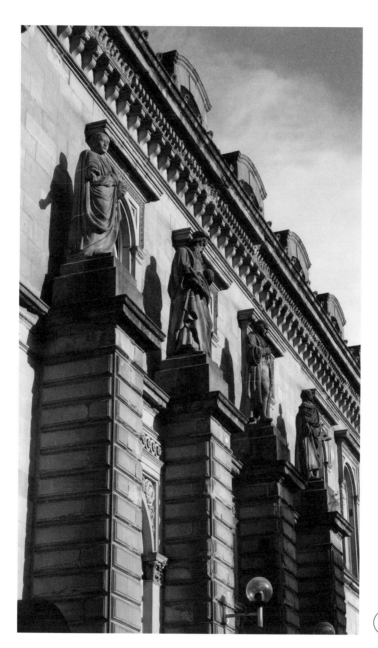

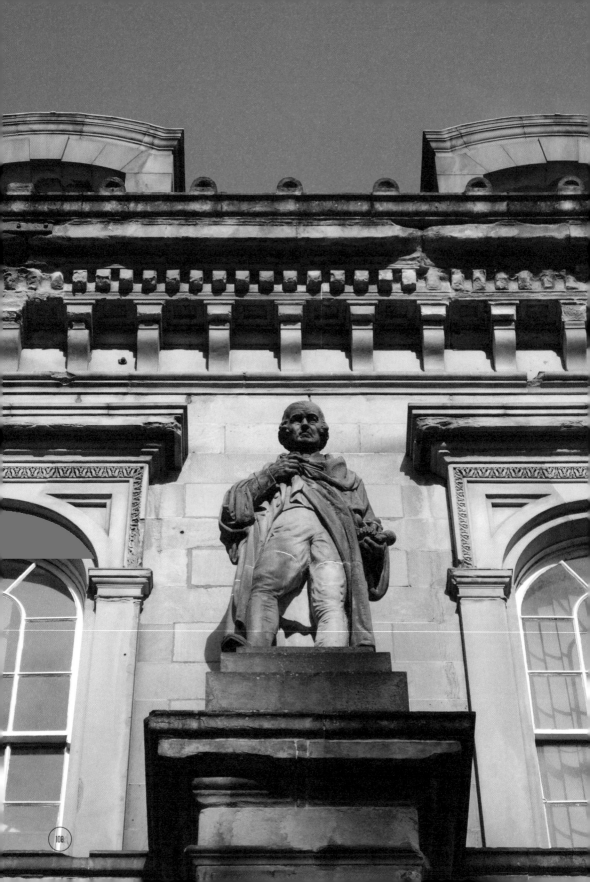

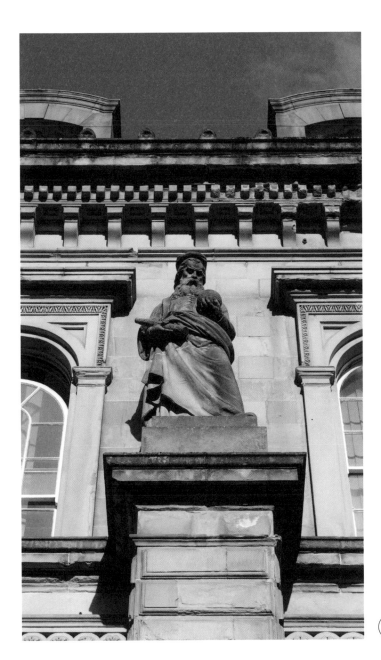

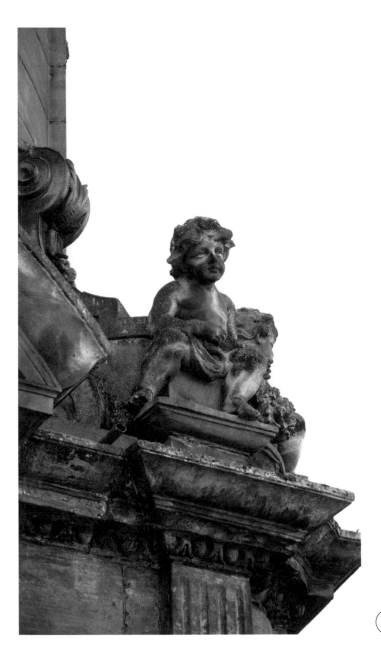

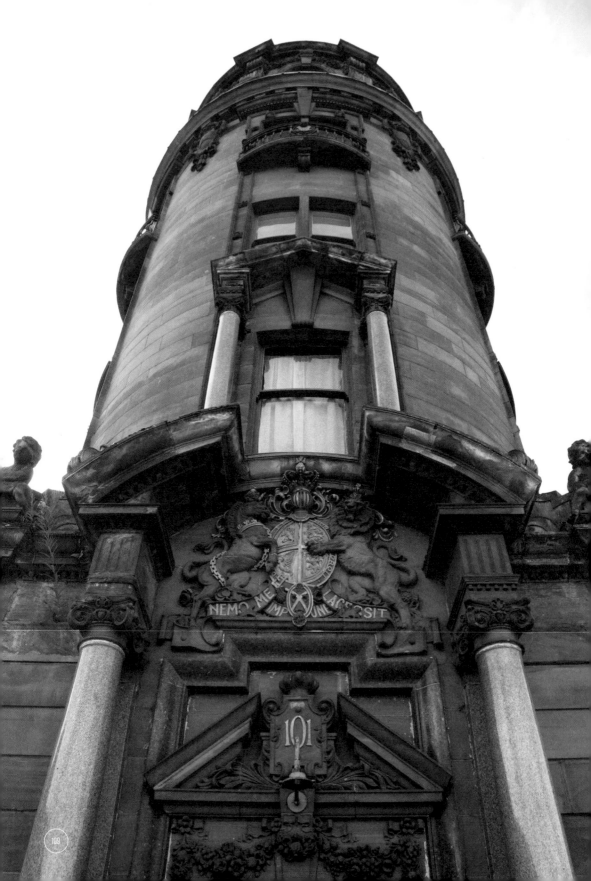

REFERENCE

105. Mitchell Library
201 North Street
Allegorical Figures of Wisdom and Literature

Sculptors: Johan Keller
and Thomas John Clapperton (1909)

In his speech at the opening ceremony
the guest of honour, the Earl of Rosebery,
committed a gross faux pas when he
referred to the library as 'this cemetery
of books' — nobody knows why he said
such a blatant untruth, but it certainly
gained him no friends and, in the great
traditions of any vendetta, he was still being
hounded by the Glaswegian press over
twenty years later.

Seated on a throne above the entrance
to the Mitchell Library is the stern, hooded
figure of Wisdom, whilst high up on the
central dome we see Literature, running
forward with robe blowing in the wind,
eager to hand us the scroll she is holding.
Along the Granville street side we can see
the façade with its solemn rank of statues.
That is all that remains of St Andrew's
Halls, which was gutted by fire in 1962
and turned into a wing of the library.

There were allegations of favouritism
when it was revealed that William B.
Whitie, former assistant to the city
engineer, had been awarded the contract
to build the library over seventy six
other submissions. The original plan was
for the building to be without dome,
ornamentation or statues, as they were
thought to be too expensive, and it is a
mystery how the project was completed
as we see it today when the budget was
barely exceeded.

106. St George's Mansions
63 St George's Road

Architects: Burnett and Boston (1900–01)

St George's Mansions were designed for
the City Improvement Trust; the back
court was conceived as a saloon serving
the shops. Across the façade of the red
sandstone tenement, we see three pairs
of winged cherubs, each with individual
shields bearing elements from the arms of
Glasgow: a bell, a tree, and a bird.

107. Charing Cross Mansions
540–46 Sauchiehall Street
Figurative Programme

Sculptor: William Birnie Rhind (1889–91)

Surrounding the central clock face are
five pairs of figures emblematic of the
seasons, commerce, industry, and others.
The decision to name the building Charing
Cross Mansions, after the London district
of the same name, elicited fierce criticism
at the time.

108. Former High School of Glasgow
94 Elmbank Street
Statues of Cicero, Galileo,
James Watt, and Homer

Sculptor: John Mossman (1878)

Above the entrance to this former high
school are sculptures of four learned figures
— Roman orator Cicero, the Greek epic
poet Homer, Italian mathematician
and astromoner Galileo and Scottish
Engineer James Watt, who invented
the steam engine.

109. 101–3 New City Road
Allegorical Figures,
Putti and Associated Decorative Carving

Sculptor: unknown (c.1910)

The main component of the sculpture
programme on this Edwardian Baroque
building erected for the Glasgow Savings
Bank is a group of cherubs and two female
figures; the one on the left holds a model
ship and represents Shipbuilding, whereas
the one on the right represents Commerce.

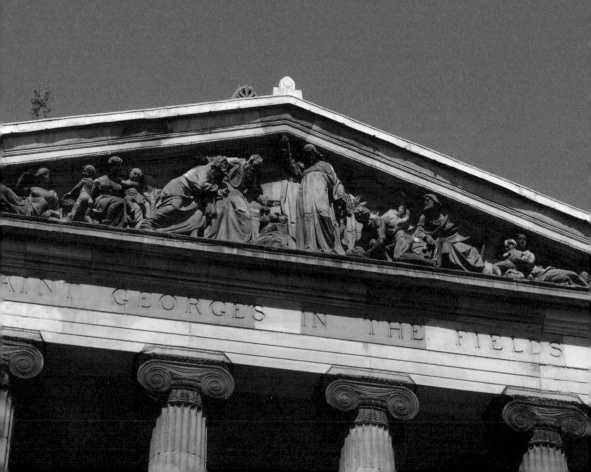

LOOK UP GLASGOW
WEST END

Hermony /
The Seein Distance

Sophie Cooke

The distance atween
twa frequencies o soond
is whit perfects thaim,
heard thegither.

Yer stanes cam awa
fae thair cauf-grund tae shape
an airt whance ye micht
leuk back on it.

Nae city's sic a city as it thinks,
no sae faur fae the laund lain aneath it.
Glesgae lilts, at shairp twaloors, tae its redd —
stanes tae their rocks, glass tae its sandy bed —
I cam miles awa fae ye, juist tae fare
the seein distance whilk isnae thare.

Harmony /
The Seeing Distance

Sophie Cooke

The distance between
two frequencies of sound
is what perfects them,
heard together.

Your stones came away
from their birth-ground to make
a place where you might
look back on it.

No city's such a city as it thinks,
not so far from the land lying beneath it.
Glasgow lilts, at open noon, to its spawning-bank —
stones to their rocks, glass to its sandy bed —
I came miles away from you, just to travel
the seeing distance which isn't there.

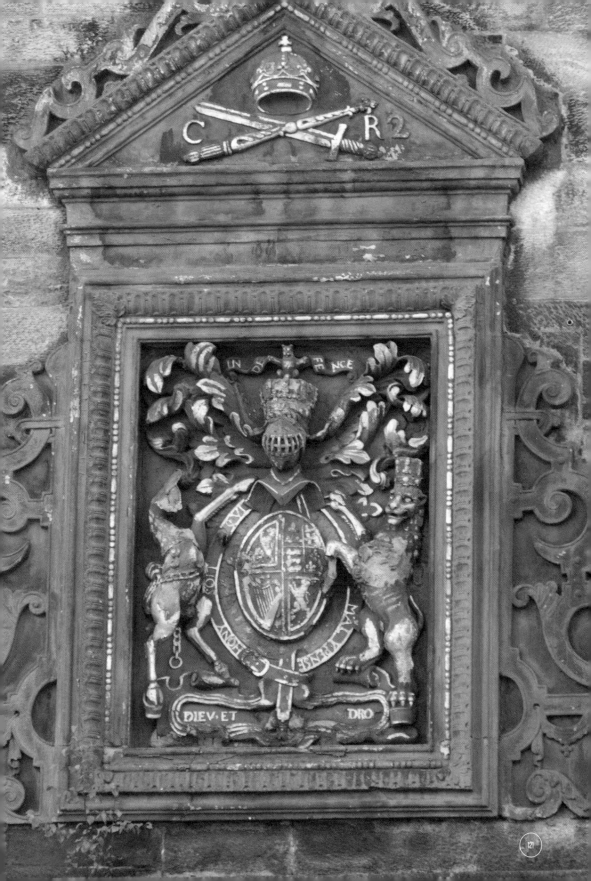

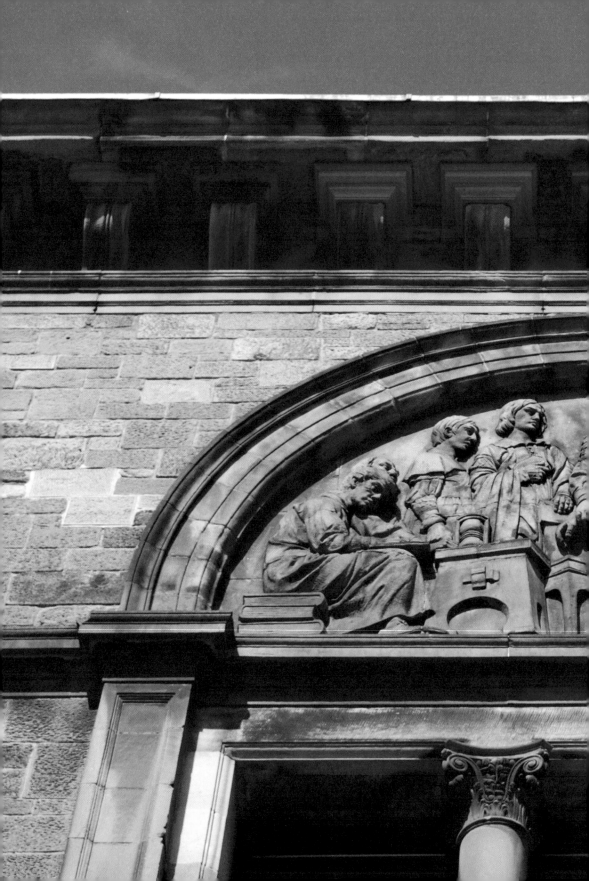

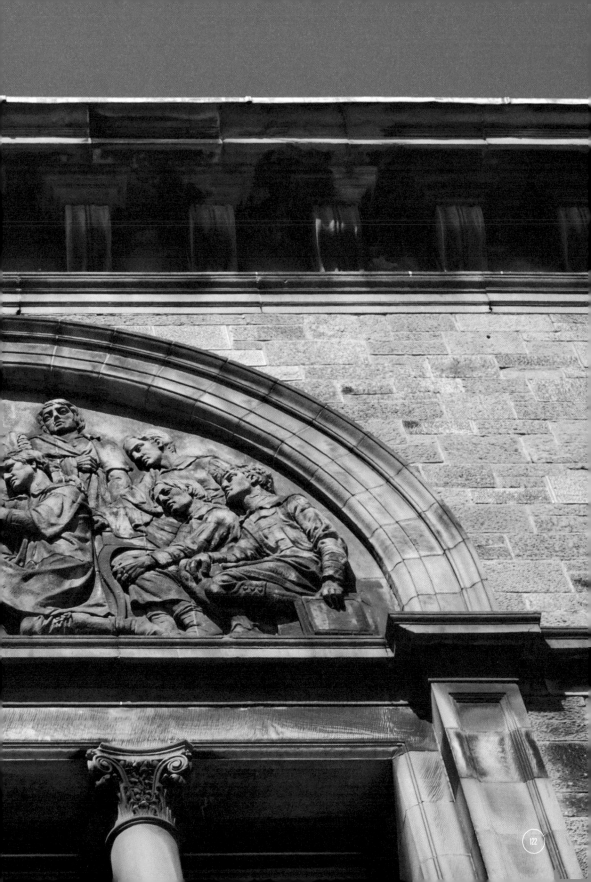

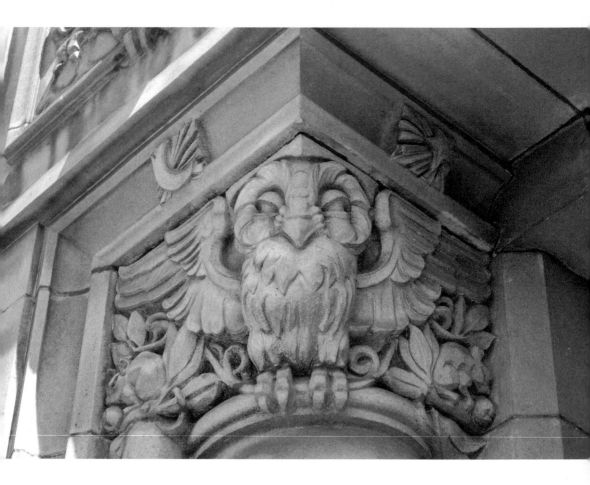

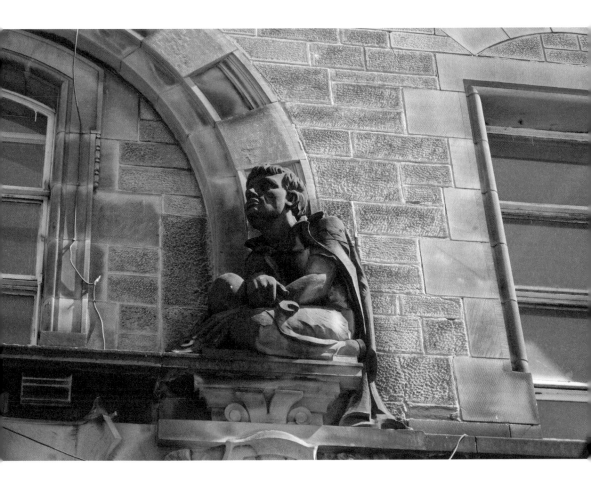

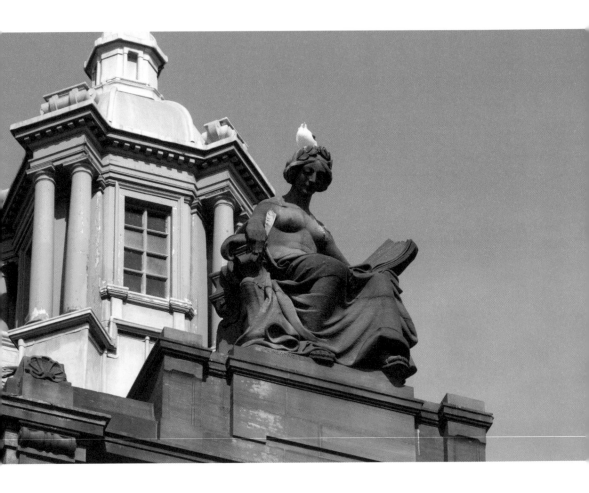

Literature
(Kelvingrove Art Gallery)

Vicki Feaver

Quill pen in one hand,
open book in the other,
Virginia Woolf hairstyle,
olive wreath headband,
draped Grecian frock,
she looks as if she set out
for a fancy-dress party,
waylaid by an evil enchanter
who turned her to red stone,
condemning her to sit
on a high parapet.

Anyone else, you'd worry,
seeing her with one toe
over the edge. But oblivious
to rain, hail, gales, pigeon shit,
and even to the occasional
brickbat thrown at her —
'mad woman in the attic',
'hyena in petticoats' —
she's only interested
in what's happening
below; patiently,
persistently, sifting
whatever comes her way.

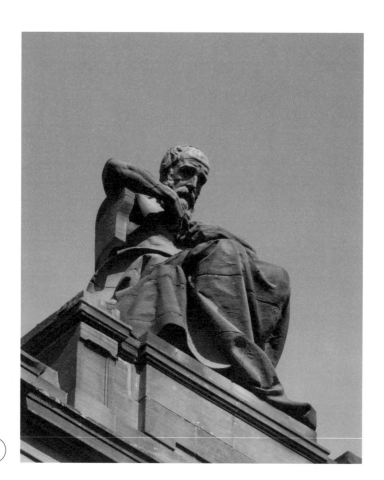

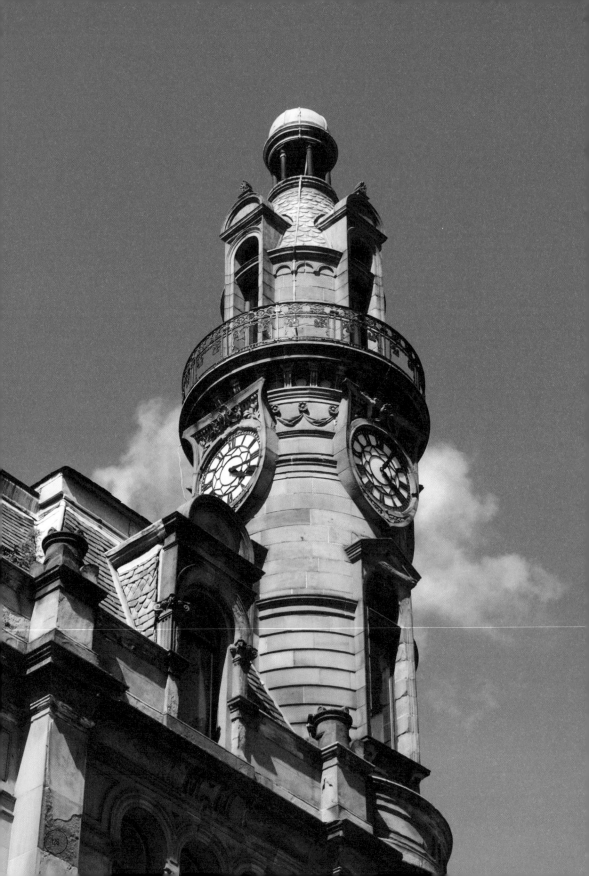

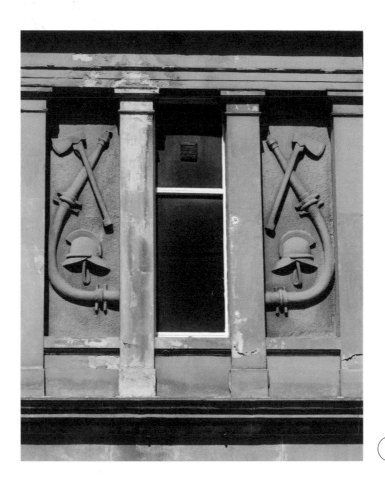

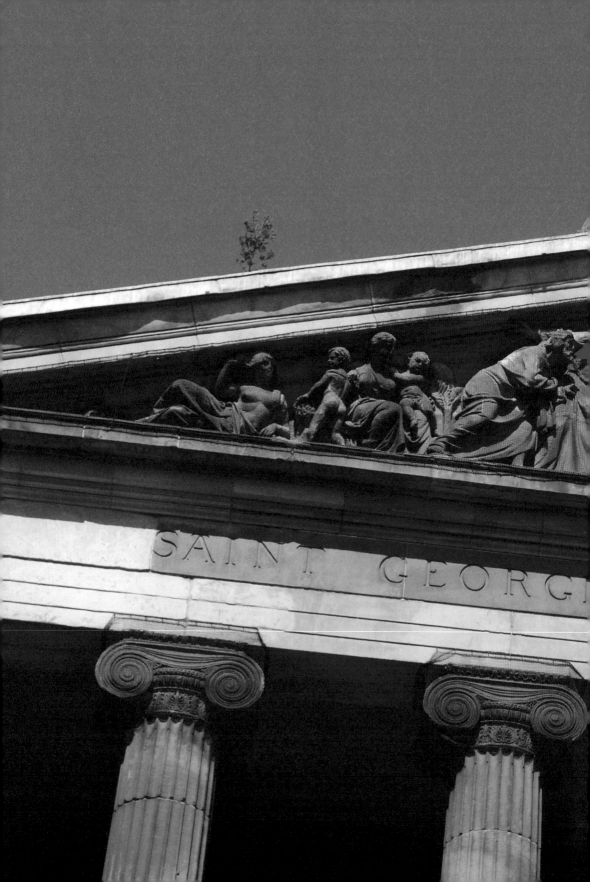

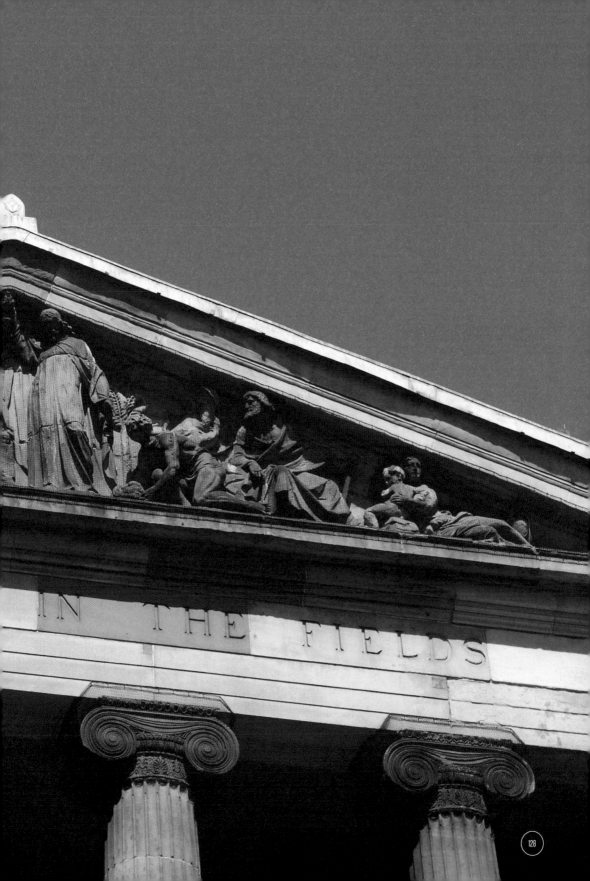

REFERENCE

120. Bishop's Mill
206–12 Old Dumbarton Road

Bishop's Mill is one of the oldest industrial locations in Glasgow, completed on the site of an earlier mill in 1853 for William Wilson, miller and grain merchant. The use of this location for milling goes back to medieval times, when the archbishopric had a monopoly on milling rights.

121. Pearce Lodge (East Gatehouse)
University of Glasgow
Corner of University Avenue
and Kelvin Way

Decorative Carving and Inscriptions

The building was erected between 1884–8, salvaging the remains of the University's original gatehouse, built in the mid-17th century which was torn down following the University's decision to move from High Street to the faux-Gothic Gilmorehill building. Only a small amount of the original decorative carving could be saved.

122. Anderson College of Medicine
56 Dumbarton Road

Narrative Tympanum Relief
and Two Winged Figures

Sculptor: James Pittendrigh Macgillivary (1888–9)

This university building features a bearded teacher lecturing a class of eight medical students, who are all looking more or less bored or unhappy. The unfortunate doctor may well not be the building's namesake, John Anderson, but Peter Lowe, who founded the Royal College of Physicians and Surgeons of Glasgow.

123. Tennent Memorial Building
38 Church Street

Allegorical Figures of Night and Day
and Associated Decorative Carving

Sculptor: Archibald Dawson (1933–5)

These perching figures on a former eye infirmary symbolise night and day; Night is a blind female in a posture suggesting repose — and Day is a more alert male, holding a spanner and a cog wheel. The two figures are modelled after the sculptor and his wife.

124. Kelvingrove
Art Gallery and Museum
Argyle Street

Sculpture Programme

Sculptors: Edward George Bramwell, Aristide Fabbrucci, George Frampton, Johan Keller, William Birnie Rhind, Archibald Macfarlane Shannan and Francis Derwent Wood (1892–1902)

The development of the Kelvingrove Art Gallery and Museum was spurred by the growing inadequacy of the previous premises and by the Glasgow International Exhibition of 1888. Its eclectic exterior bears elements of Spanish Renaissance style. The various seated figures mirror the building's general eclecticism by representing the Arts, Music, Literature, Science, and Commerce amongst others.

125. Kelvin Hall
1445 Argyle Street

Architect: Thomas Gilchrist Gilmour (1926–27)

The Kelvin Hall was a popular arts and sports venue which opened as an exhibition centre in 1927 after the previous wooden hall, designed by Robert James Walker for the 1901 Glasgow International Exhibition, burnt down in 1925. From 1987 to 2010, it was a home to Glasgow's Museum of Transport.

126. Cooper's Restaurant and Bar
499 Great Western Road

Architect: R. Duncan (1886)

The tall slender tower of this flamboyant French Renaissance building is perhaps its most remarkable feature, with clock faces and a roof with a lantern. The building was originally a fancy supermarket called Coopers Fine Fare.

127. Former North Fire Station
509 St George's Road

Wall decoration

This building used to be the home of North Fire Station, serving the north of the city which was prone to fires due to its distilleries and factories. The Glasgow Herald reported on the 'latest and most approved sanitary improvements' on the building's opening in 1889. The firemen used to live in the building itself.

128. Former Church
of St George's in the Fields
485 St George's Road
Christ Feeding the Multitude

Sculptor: William Birnie Rhind (1885–6)

Christ, in the centre of this large relief,
is flanked by a number of beneficiaries,
including some elderly men, a mother with
children, and a semi-naked female figure.
The scene is an allusion to the biblical
miracle of the five loaves and two fishes;
present-day culinary preferences in the area
may differ.

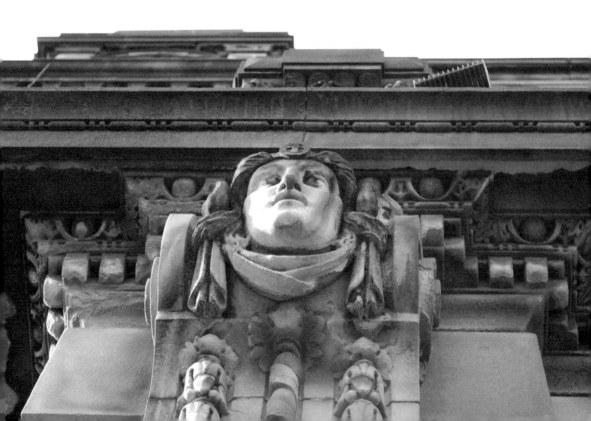

LOOK UP GLASGOW
EAST END

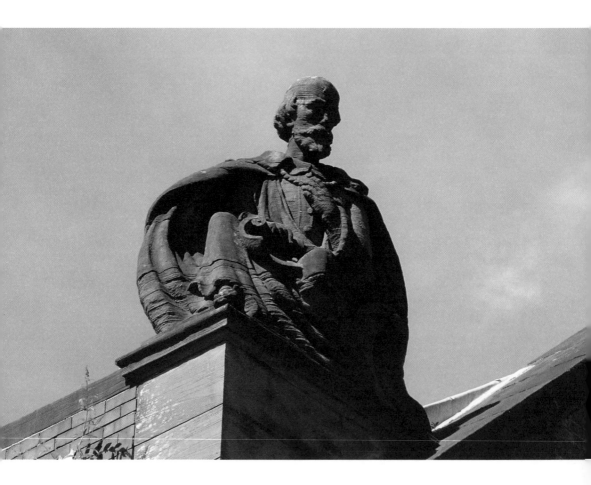

listen to the stone

Jim Carruth

Now is the time to listen
to the guardians in stone.

Open your eyes as ears
to what their silence says.

They'll not have you face them
as equals so lift your head

pay homage to the city builders
to empire, commerce, past glories

to walk the street below is
to be complicit in this trade off.

Look long enough to know
what is really being said

behind the façade,
then look away.

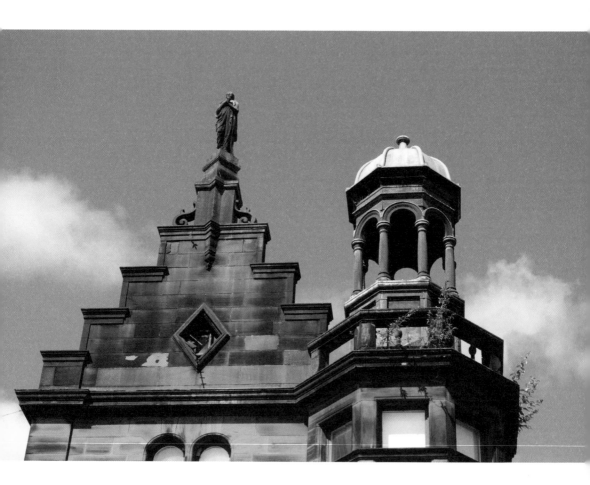

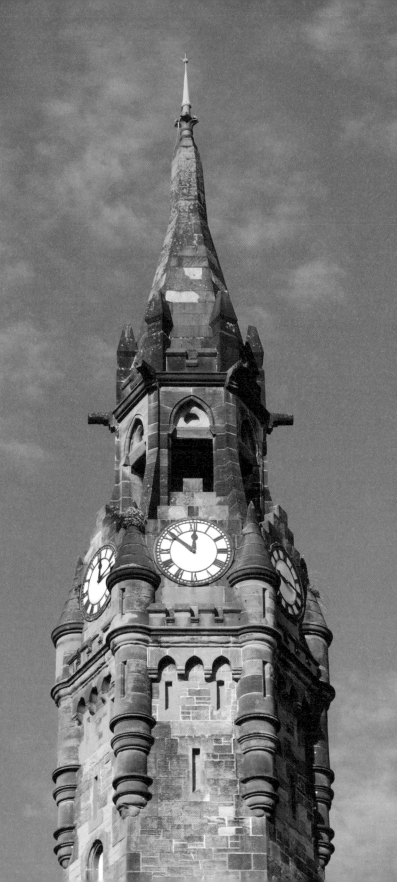

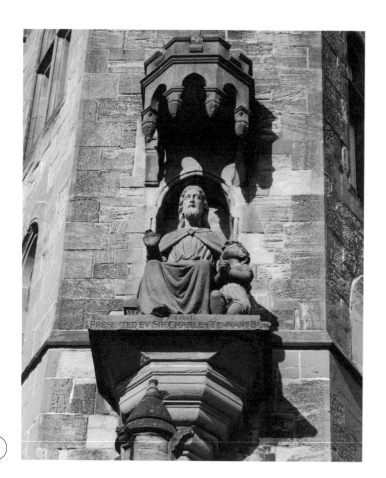

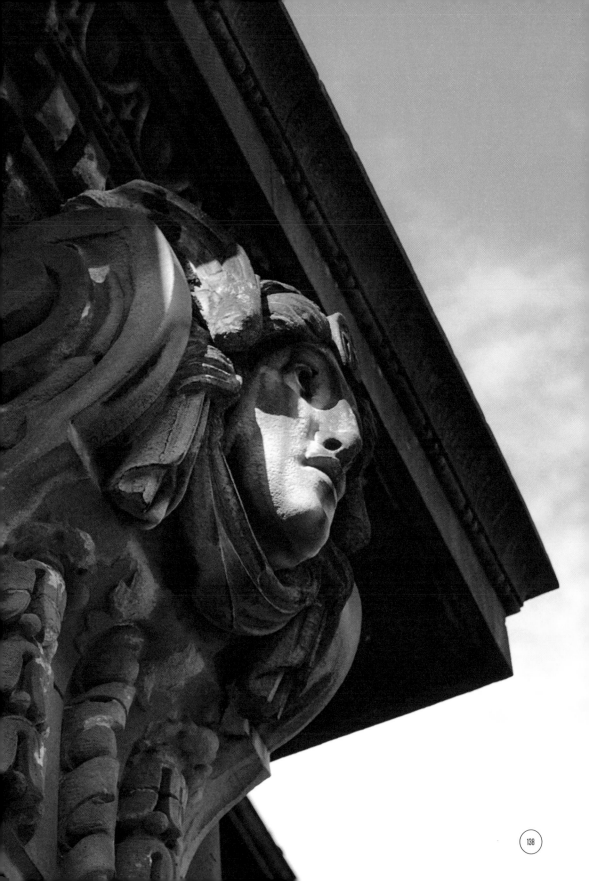

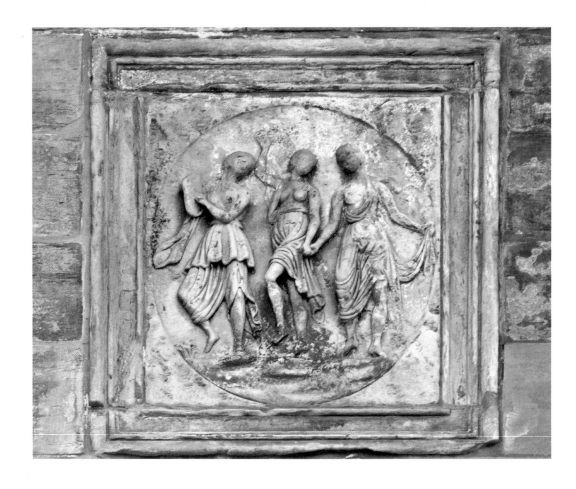

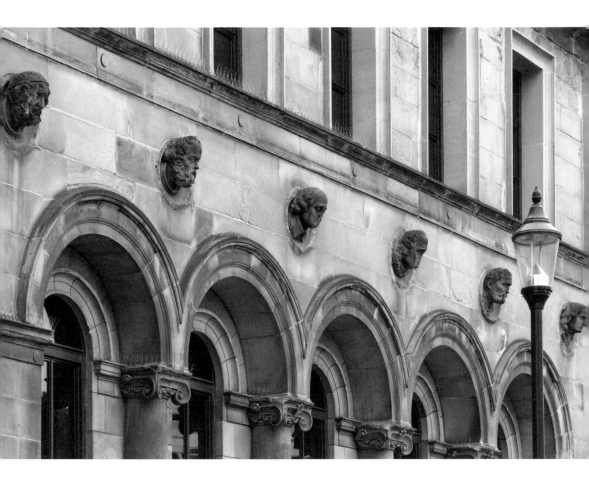

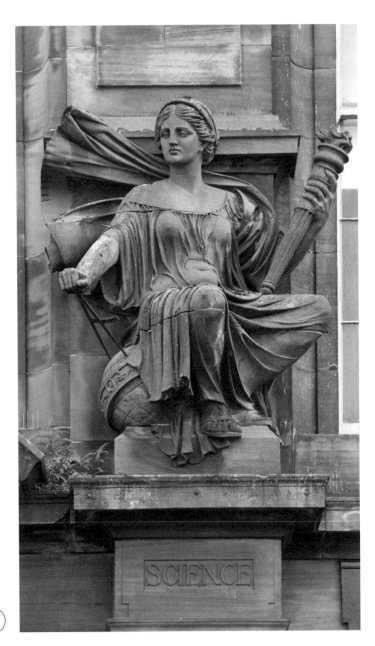

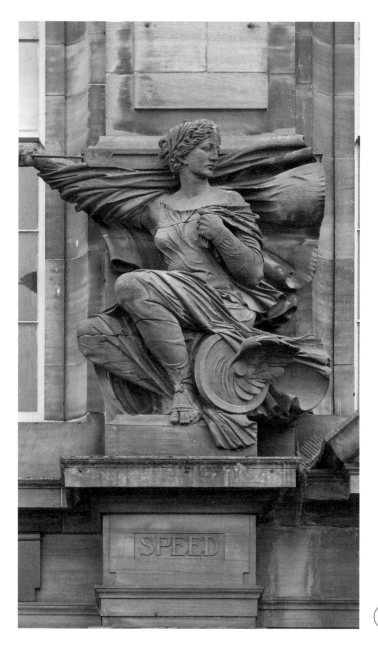

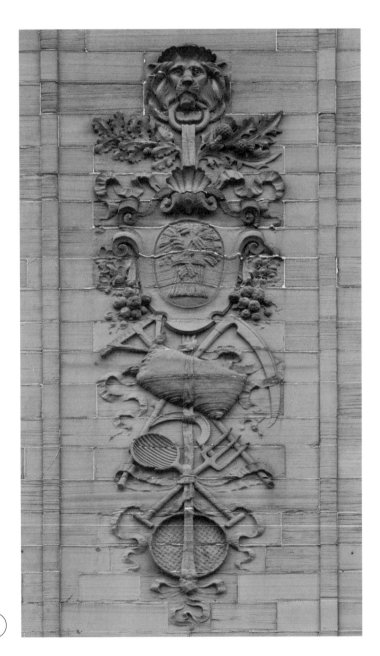

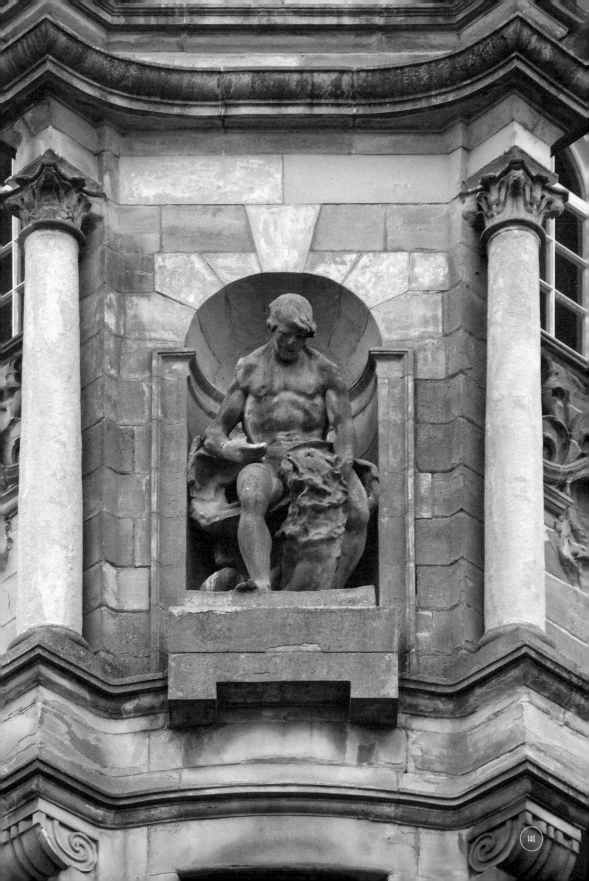

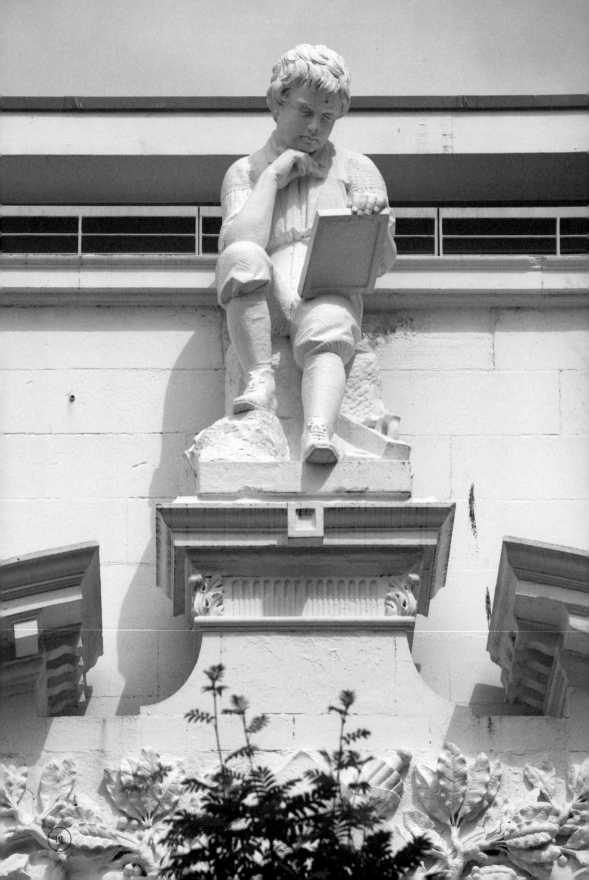

faces

Jim Carruth

faces in stone
appear to change
through the day

light and dark
release their bodies
from an earthly hold

the flawless young
flit in and out
of the shade

only men portrayed old
wisdom etched
by weathering

symbols come and go
rare days of bright sun
swallow them whole

in the shadow
of tall buildings.

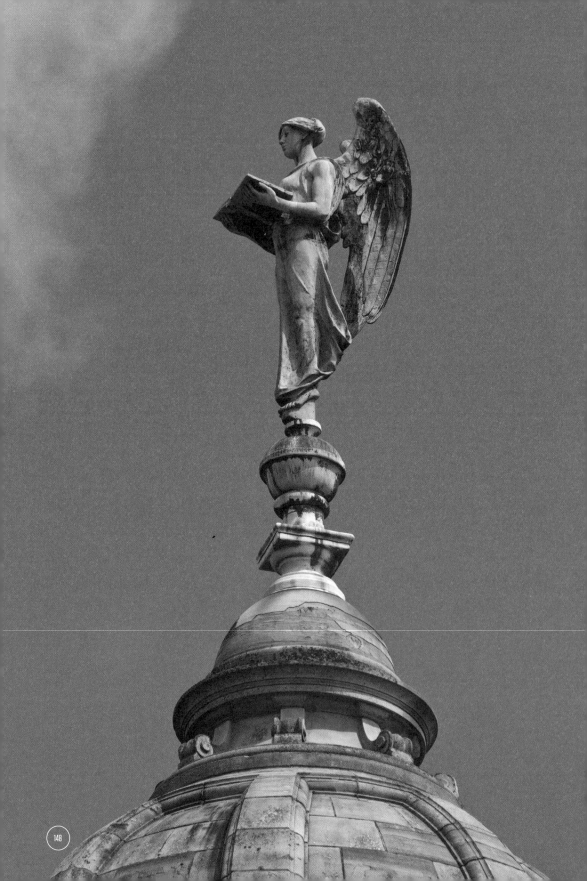

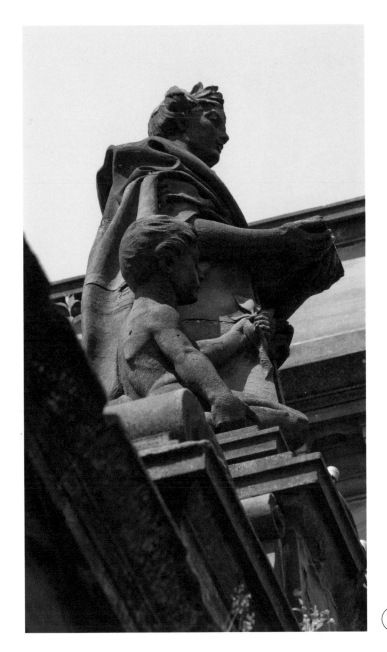

REFERENCE

135. Glasgow District Court
54 Turnbull Street
Allegorical Figures of Law and Justice
and Associated Decorative Carving

Sculptor: Richard Ferris (attrib.) (1903–6)

This Turnbull Street building was originally the Central Police Office, but retained its association with law enforcement as a District Court. Observing passersby critically are Law, a bearded man holding a scroll, and Justice, a non-bearded woman holding a sword and a set of scales.

136. 215 High Street
7–9 Nicholas Street
Allegorical Female Figure, Commemorative
Plaque and Decorative Carving

Sculptor: unknown (statue);
William Forrest Salmon (plaque) (1895)

Yet another building originally designed as a bank, this particular one was a *fin de siècle* construction for the British Linen Company. Although the statue atop this building appears in a pose of supplication, no specific allegorical meaning has been identified. We are open to suggestions.

137. Former Royal Asylum for the Blind
92 Castle Street
Christ Healing a Blind Boy

Sculptor: Charles Grassby (1881)

A sculpture of Christ, described in an account published after its installation as 'of heroic size', is a prominent feature of the former Royal Asylum for the Blind. The building was derelict after having been annexed by the Royal Infirmary in 1989, and has now been converted into flats.

138. Glasgow Royal Infirmary
84 Castle Street
Statue of Queen Victoria
and decorative carvings

Architects: James Miller (1914)
Sculptors: Albert Hodge

These beautiful heads can be found on the southern façade of the Royal Infirmary, looking out onto Cathedral Square. Above them is a colossal bronze statue of a very stern Queen Victoria, who does not look very amused by her 63 years on the throne. She, and the building she sits on, brought James Miller a barrage of criticism for building something that competes so strongly with the adjacent cathedral.

139. Glasgow Evangelical Church
14–20 Cathedral Square
Statues of the Apostles
and Associated Decorative carving

Architect: John Honeyman (1878–80)

This highly ornate, Italianate-style church which dominates the south-eastern corner of Cathedral Square was built in 1878-80 to a design by John Honeyman. It provided new accommodation for the Duke Street United Presbyterian congregation when forced to move from its premises due to the new and extensive railway developments facing onto High Street. The number of statues is highly unusual for a Presbyterian Church, who post-Reformation frowned upon 'any graven image'.

139. McLennan Arch
Glasgow Green, Saltmarket Entrance
opposite Justiciary Court
Classical Relief Panels

Sculptor: unknown (c.1796)

Two decorative panels on the McLennan Arch show scenes from classical mythology: on the left, Orpheus playing a lyre, and on the right, the Three Graces dancing, one playing a tambourine (pictured). The arch was modelled loosely on the triumphal arches of Imperial Rome.

141. The People's Palace
Glasgow Green, near the east end
of Monteith Row
Nine Allegorical Figures

Sculptors: William Kellock Brown
(figures); James Harrison Mackinnon
(decorative work) (1894–8)

This impressive, three-storey domed
structure houses the city's museum of
popular history and features female figures
on the front and a glass Winter Garden to
the rear. The People's Palace was originally
built as a counterpart to the Kelvingrove
Museum in the more affluent west end.

142. Templeton Business Centre
62 Templeton Street
Allegorical Female Figure and Associated
Decorative Carving

Sculptor: unknown (1888–92)

Atop this remarkable variation on the
fortified Gothic style which is basely
loosely on a Venetian palace, we find
a crowned female figure symbolising
the textile industry. More hidden away,
there is a Glasgow coat of arms amongst
other decorative carving. The lavishness
of the building's decoration and multi-
coloured brickwork is highly incongruous
considering the original use of the building:
a carpet factory.

143. Former Ladywell Public School
94 Duke Street
Six Portrait Roundels

Architect: John Burnet Sr. (1858)

This A-listed building of Italianate
composition was originally designed as the
Alexander's Endowed School, an adjunct
to R F & J Alexander's Cotton Thread
Mill. It then housed the Ladywell Public
School for a number of years, before being
converted to a business centre with a
substantial modern extension to the rear.

144. Former Locomotive Works
110–36 Flemington Street
Allegorical Female Figures of Speed and
Science, with Associated Decorative Carving

Sculptor: Albert Hemstock Hodge
(attrib.) (1909)

Speed and Science are here represented
as women in billowy gowns, riding on
a winged chariot and sitting on a globe,
respectively. Centrally, we see an image
of the front of a locomotive to complete
the references to engineering, science,
and travel found across the building.

145. Tenement Building
202–4 Hunter Street
Trophy of Agricultural Implements
and Produce

Sculptor: unknown
Architect: J. Gordon (c.1902)

This very large trophy adorns the area
between the windows on the first and
second floors of a red Locharbriggs
sandstone building, which was erected by
seed merchants. Some highlights include
a sieve, a sickle, a bulging sack, a scythe,
and a pitchfork.

146. Former Parkhead Savings Bank
1148–56 Gallowgate
Prudence Strangling Want

Sculptor: Archibald Macfarlane Shannan
(1908–9)

Prudence, in masculine form, is here
growled at by Want, a wolf at his knees.
The Baroque style reflects a common trend
in Glasgow's large public buildings from
the turn of the century period.

147. Former Greenview School
47 Greenhead Street

The Mathematician

Sculptor: William Brodie (1873–4)

On this building's west wing, a boy of
about ten years of age sits on a rock; this is
The Mathematician. He is holding a slate
and a piece of chalk rather than the more
stereotypical abacus — probably suffering
through long division. The boy's humble
garments and the group of carpenter's
tools at his feet hint at the opportunity
for improving his social standing through
vigorous study.

148. Dennistoun Public Library
2a Craigpark

Figurative Programme

Sculptor: William Kellock Brown
(attrib.) (1905)
Architect: James R. Rhind

This is another of Glasgow's public
libraries designed by James Rhind; it, too,
features a winged female figure holding
an open book, draped in a classical tunic.
These libraries, built in the early twentieth
century, were part of an effort to augment
the existing centralised services provided
by the Mitchell and Stirling's Libraries.
Scottish magnate Andrew Carnegie made
a substantial contribution to their funding.

149. Parkhead Public Library
64–80 Tollcross Road

Figurative Programme

Sculptor: William Kellock Brown (1906)
Architect: James R. Rhind

This is the most complex of Rhind's seven
libraries built for the Glasgow Corporation,
located on a corner site. The sculpture
programme includes the angel atop the
dome, holding an open book, as well as
figures seated on pedestals, and another
group featuring a female figure, also
holding an open book, with two children
at her feet.

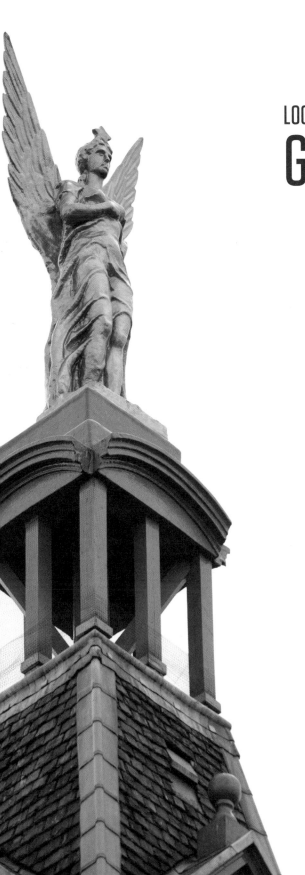

LOOK UP GLASGOW
GOVAN

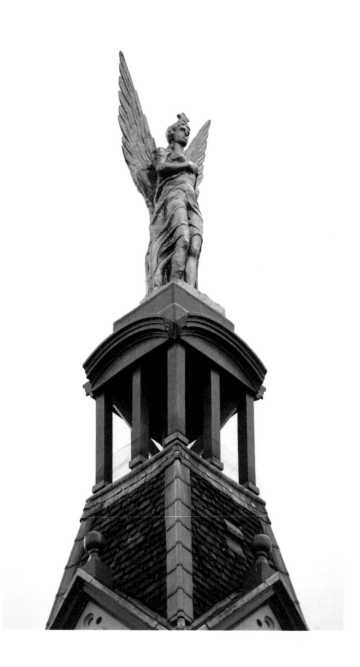

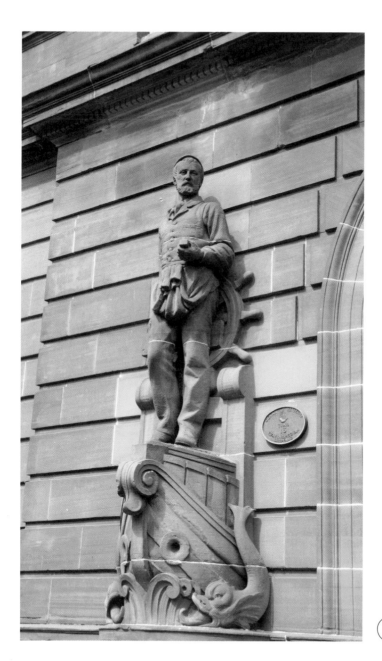

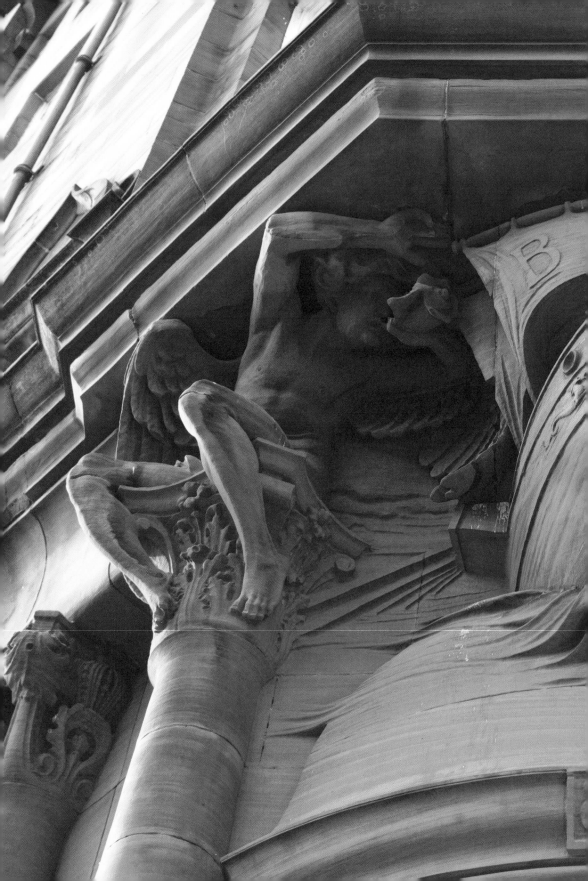

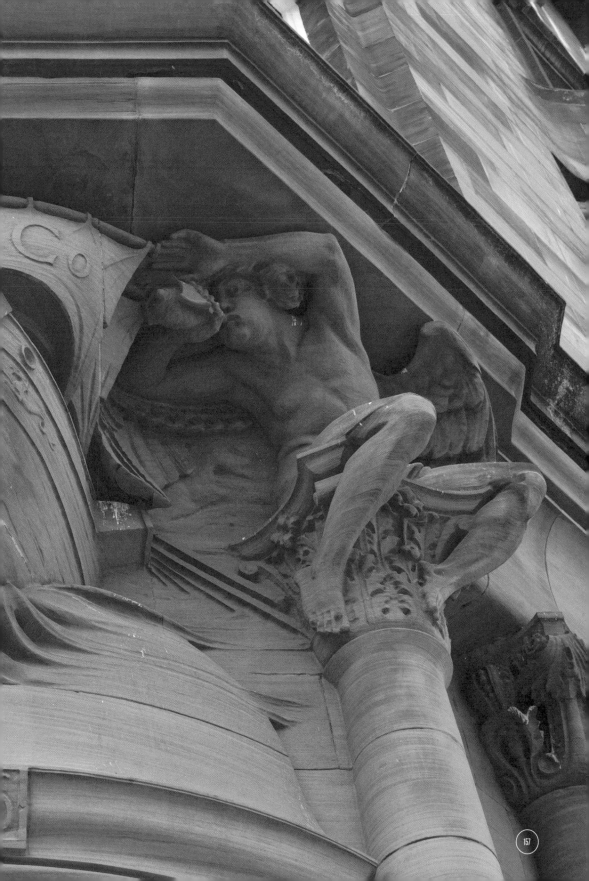

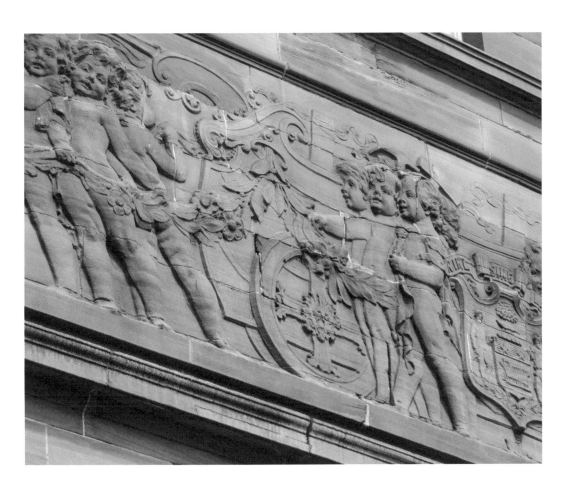

REFERENCE

155. Angel Building
2–20 Paisley Road West
Angel

Sculptor: unknown (c.1885)

An entirely gilded angel rests atop a roof on the south-east tower of a tenement building; its origins are almost completely unknown — one of the great enigmas of nineteenth-century Glasgow. Not only does it seem to be missing a matching piece on the adjacent north tower, the symbolism of the star on its head has also never been unravelled. While the Angel Building is not in Govan parse, its prominent position on Paisley Road West acts as a marker for those approaching Govan proper from the city centre.

156. BAE Systems
(former Fairfield) Yard Offices
1030–48 Govan Road
Engineer, Shipwright
and Associated Decorative Carving

Sculptor: James Pittendrigh Macgillivray (figures) and McGilvray & Ferris (reliefs) (1890)

Commissioned by Sir William George Pearce, this building features an arrangement of figures strongly reminiscent of the traditional design of the Govan coat of arms; the engineer and shipwright on the building recall Govan's draughtsman and ship's carpenter. Acquired by the Norwegian firm Kvaerner in 1988, the building's use of Viking imagery was appropriate during their 11 year ownership until its sales to BAE Systems in 1999.

157. Bank of Scotland
(former British Linen Company Bank)
816–818 Govan Road
Zephyrs, Figurative Capitals
and Associated Decorative Carving

Sculptors: Francis Derwent Wood and Johan Keller (modellers); Richard Ferris (carver) (1897–1900)

The sculpture programme concentrates on the pictured ship's prow emerging in full sail from beneath a window above the entrance; its stem is carved with a miniature female nude. This central piece is accompanied by winged wind gods blowing through conches into the sails of the ship.

158. Former Govan Press Building
577–81 Govan Road
Six Portrait Roundels

Sculptor: unknown (1889–90)

Six portrait medallions on this building depict a misspelt Gutenberg alongside Scott, Burns, Caxton, John Cossar — the publisher who erected the building — and his wife Jane White Cossar. Cossar was a bit of a star of the local newspaper scene, having launched two papers in his time; after his death, his wife launched another two.

159. Former Govan Town Hall
401 Govan Road
Portrait Roundels, Portrait Keystone
and Procession of Putti

Sculptor: Archibald Macfarlane Shannan (1897–1904)

The two dignified gentlemen depicted in these portrait roundels were the incumbent Provosts of Govan when the building was erected, gracing a structure that served as Town Hall and Burgh Offices and also incorporates a theatre and concert hall in the southern wing.

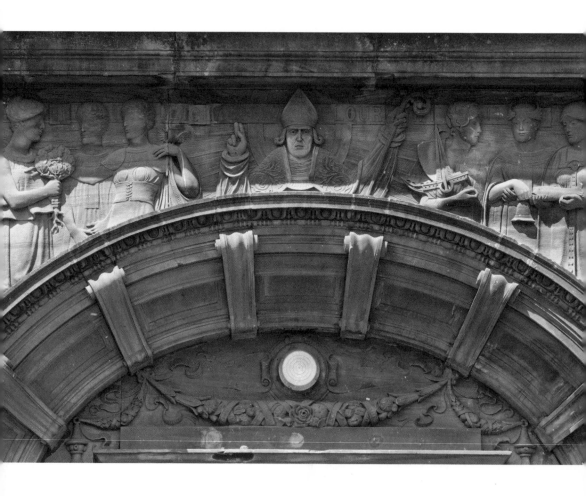

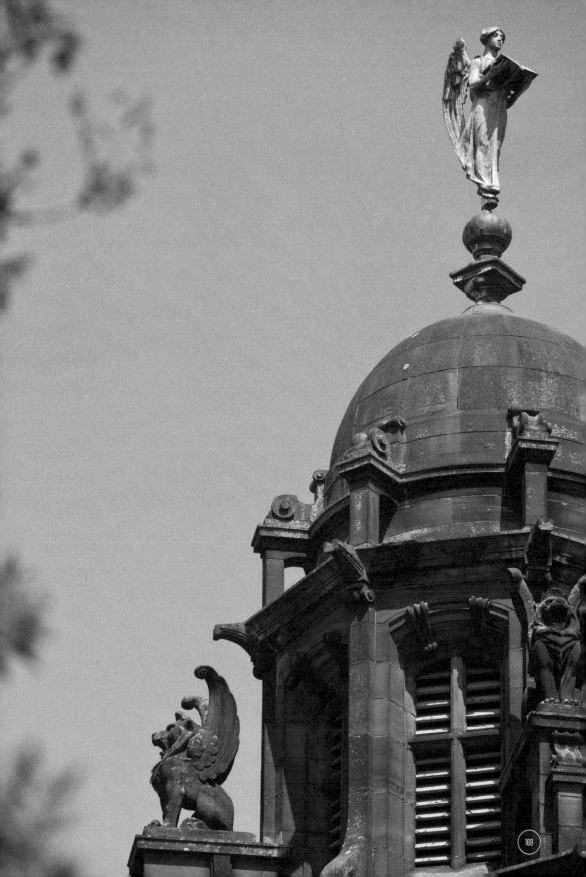

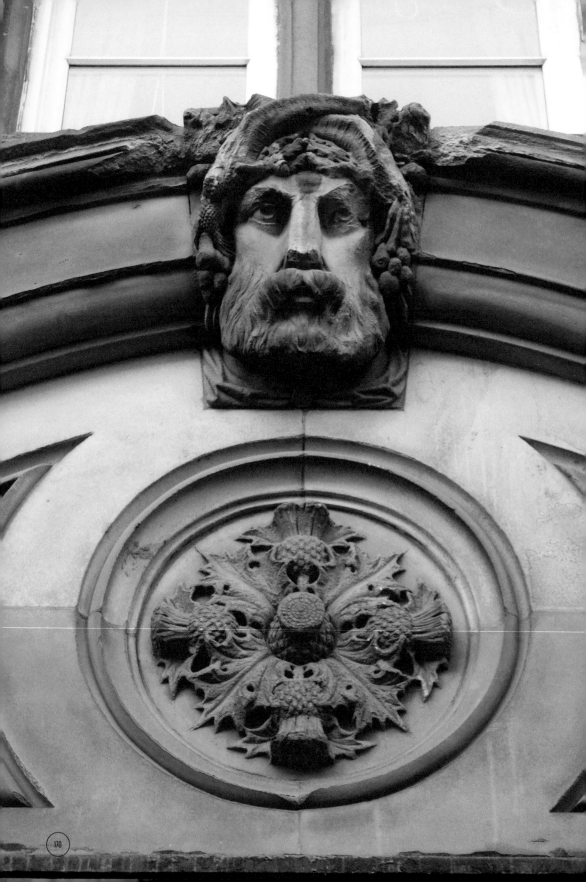

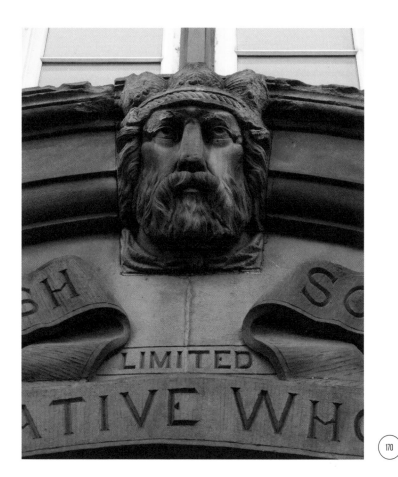

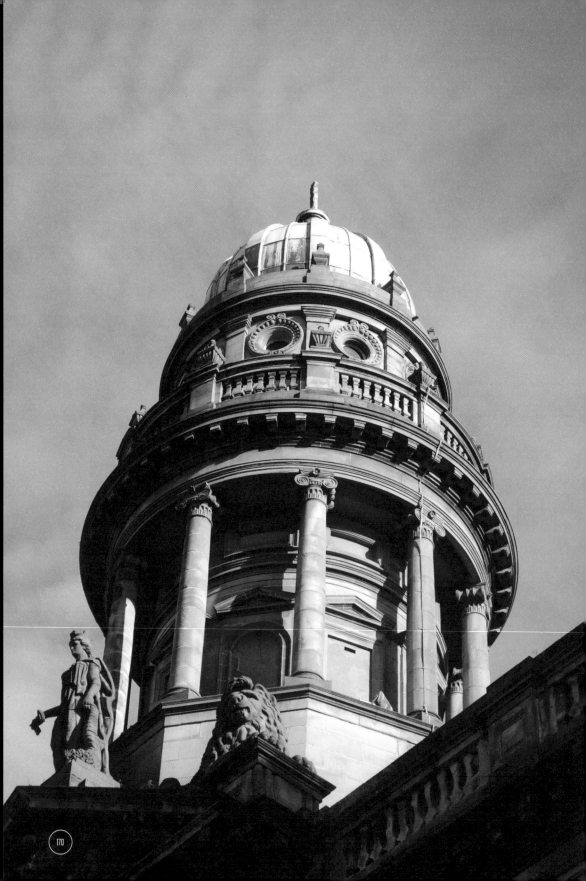

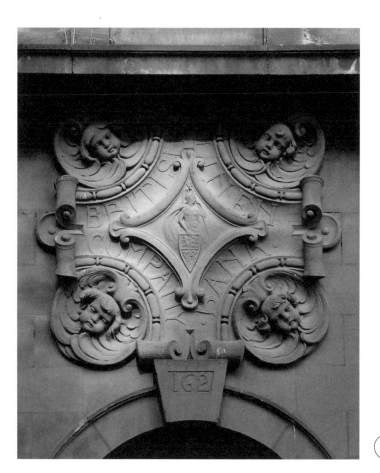

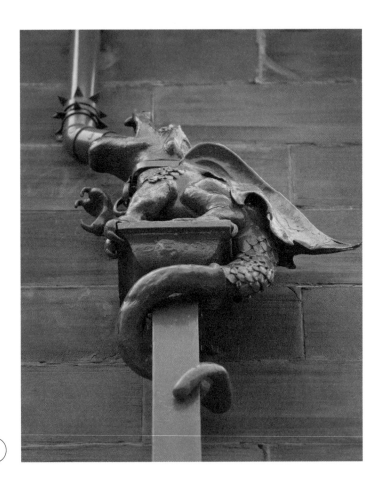



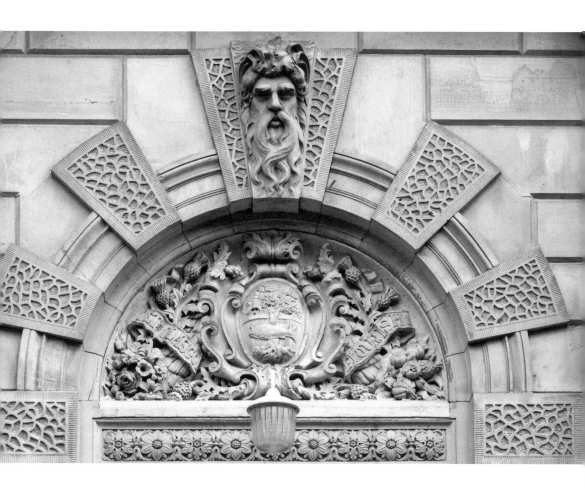

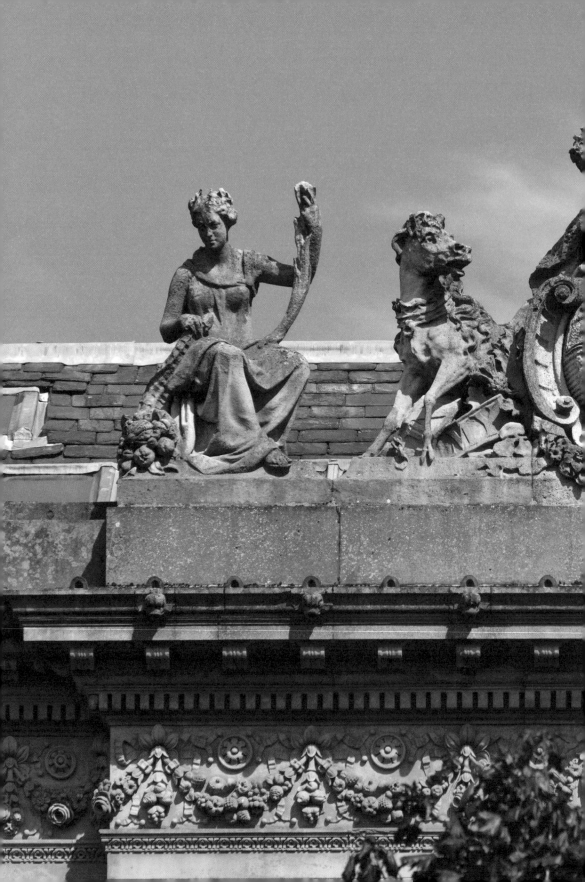

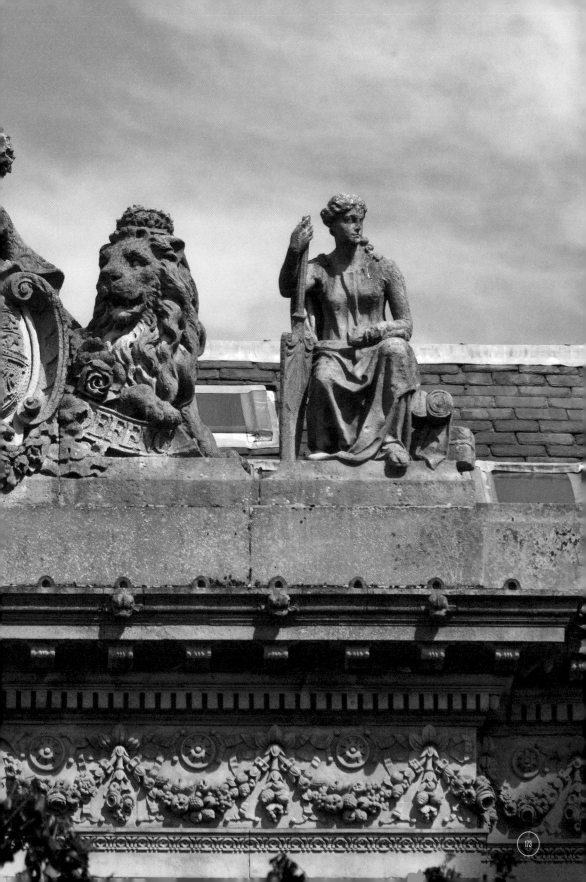

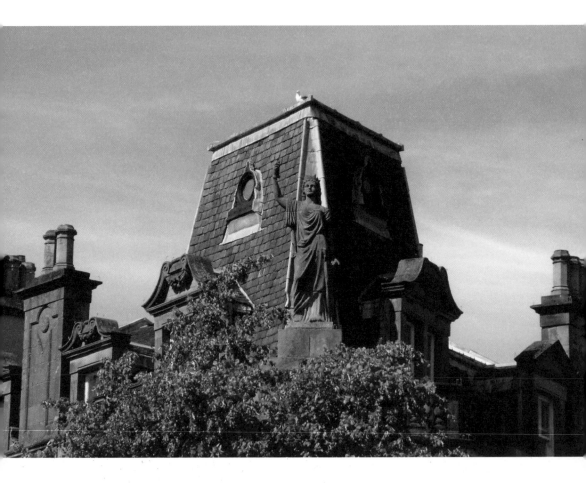

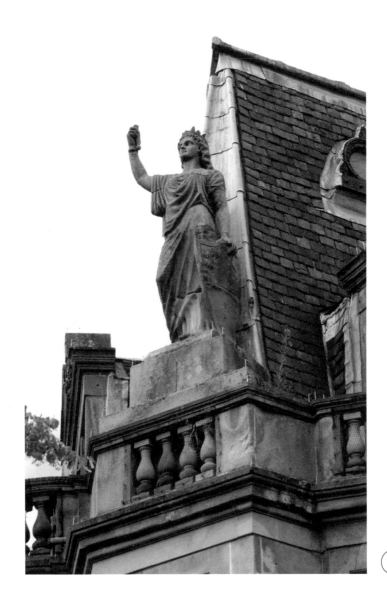

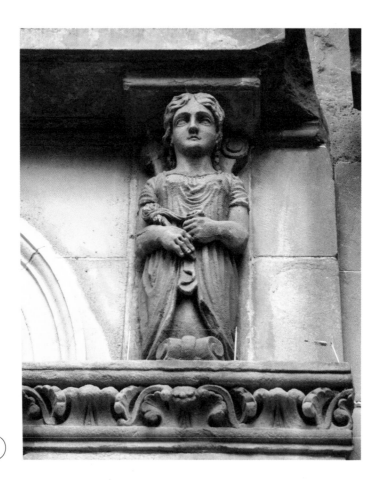

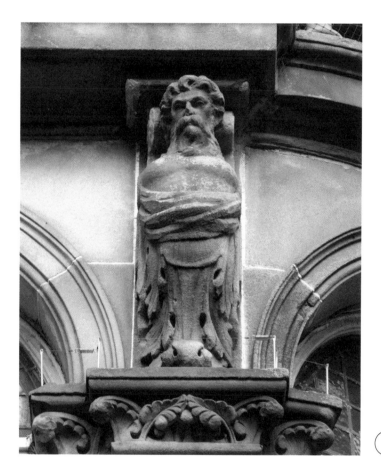

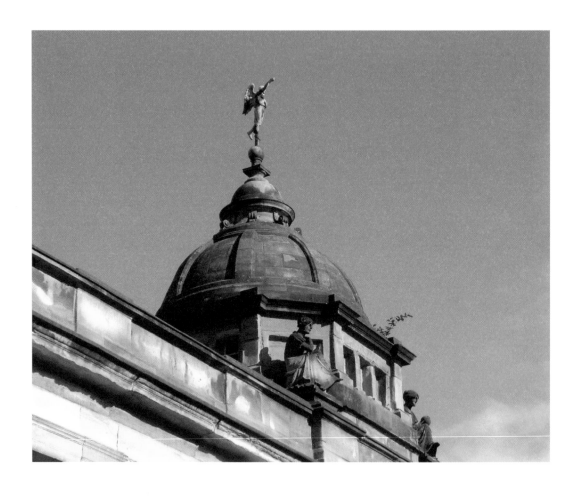

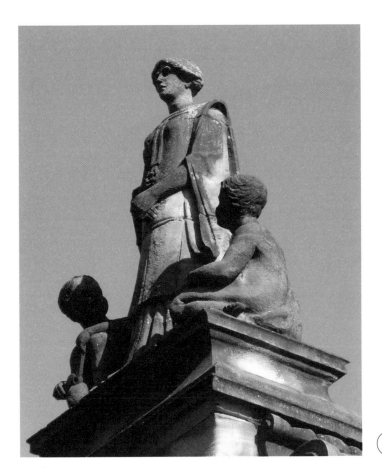

REFERENCE

169. Gorbals Economic and Training Centre (former Hutchesontown District Library)
192 McNeil Street
Figurative Programme

Sculptor: William Kellock Brown (attrib.) (1904–6)
Architect: James R. Rhind

Designed in a hybrid Elizabethan style, this building features three small turrets and a central tower, atop which an angel figure is holding an open book. It is one of seven district libraries all designed by James Rhind for Glasgow Corporation, and the dome figure on this building is identical to those on the Parkhead and Dennistoun Libraries.

170. Former Co-operative House
95 Morrison Street
Pediment Group with Acroterion Figure

Sculptor: James Alexander Ewing (1895–7)

The Co-operative Wholesale Society's trademark emblem of a pair of clasped hands is repeated several times in the sculpture group on this building, which is in the French Second Empire style; its grandeur apparently remained unaffected despite complaints about the scarcity of stonemasons in Glasgow at the time of construction.

171. Former British Linen Bank
162 Gorbals Street

Architect: James Salmon (1900)

The currently derelict building in the Glasgow Style features a lively collection of cherub masks, a royal arms, and a miniature Britannia. The building was the subject of Lisa Gallacher's public artwork *Sewing Machine* in 1999, in which she pierced the walls with a huge needle and thread.

172. McCormick House
46 Darnley Street
Various Decorative Sculpture

Sculptor: unknown (possibly William Shirreffs) (1901–2)

Tucked away in Pollokshields is this remarkable grotesque dragon swallowing a drain pipe on the outside of a three-storey commercial building in the Glasgow Style. The building's interior is also worth a look; it features an extensive programme of stained glass by W.G. Morton.

173. Langside Public Halls
1 Langside Avenue
Allegorical Figures of Commerce and Plenty and Related Decorative Carving

Sculptor: John Thomas (1847; rebuilt 1902–3)

This richly ornamented building is crowned by the British royal arms. The coat of arms is supported by a lion and unicorn, in turn flanked by two female figures representing Peace and Plenty. Remarkably, this building in its entirety once stood on Queen Street, before being reassembled stone by stone on its present site.

174. 78–118 Queens Drive
Liberty Figure

Sculptor: Unknown (1886)

Architect William M. Whyte celebrated his love of all things American by having a lady liberty figure erected on top of this Queens Drive block. The plans were opposed by a number of local baillies, whose caricatures Whyte had carved into the façade of the building, to less than flattering effect.

175. Govanhill
and Crosshill Public Library
170 Langside Road and Calder Street
Figurative Programme

Sculptor: William Kellock Brown (1906)

The bronze angel balanced on top of
the dome, known locally as 'minerva',
was stolen in June 1995 by four men
impersonating council workers. Luckily,
it was found, fixed and replaced within
a year. Locally born psychologist R.D.
Laing often looked to the statue as
a symbol of hope, as mentioned in his
autobiography, which describes a grim
and unforgiving upbringing in Depression-
ravaged Govanhill.

176. Victoria Infirmary
517 Langside Road
Puma and Coats of Arms

Carver: James Harrison Mackinnon
(1899–1900)

The campaign for a hospital on the
Southside began in 1878, but it wasn't
until 1890 that the Victoria Infirmary was
formally opened. It is relatively unadorned,
but the Puma stalking the building may
relate to a local myth about cats being able
to heal other animals by licking
their wounds.

POETS

— Kona Macphee

Kona Macphee grew up in Australia and now lives in Perthshire, where she works as a writer, mentor and media producer and generally enjoys being a thingwright.Kona received an Eric Gregory Award in 1998 and has three collections from Bloodaxe Books, *Tails* (2004), *Perfect Blue* (2010), which received the Geoffrey Faber Memorial Prize for 2010, and *What Long Miles* (2013). For more information, please visit www.konamacphee.com

— Graham Fulton

Graham Fulton's poems have been widely published in Europe and America. His collections include *Humouring the Iron Bar Man* (Polygon, 1990), *This* (Rebel Inc, 1993), *Knights of the Lower Floors* (Polygon, 1994), *Ritual Soup and other liquids* (Mariscat, 2002), *Open Plan* (Smokestack Books, 2011), *Full Scottish Breakfast* (Red Squirrel Press, 2011), *Upside Down Heart* (Controlled Explosion Press, 2012) and *Reclaimed Land* (The Grimsay Press, 2013). He lives in Paisley.

— Colin Begg

Born and brought up in Ayrshire, Colin Begg has lived and worked in Sydney, Berlin and Vancouver but always ends up back in Glasgow. A graduate of Creative Writing programs at Glasgow University and UTS in Sydney, his poems have won various awards and wide publication in literary journals. Colin is also co-founder & co-editor of *Gutter*, the magazine for new Scottish writing. A former Hawthornden Fellow, he was recently awarded a Clydebuilt poetry apprenticeship.

— Sophie Cooke

Sophie Cooke was born in London in 1976. She grew up near Callander, studied in Edinburgh, and has worked in Glasgow, London, and Berlin. She now lives in Edinburgh. She has won the Genomics Forum Poetry Prize, and been long-listed for the Montreal International Poetry Prize. Her poetry has been published in *Gutter* and *The Istanbul Review*; she has also worked on translations of poetry from Ukrainian. She likes travelling, and swimming in rivers.

— Vicki Feaver

Vicki Feaver lives between Dunsyre, South Lanarkshire, and The Shore, in Leith. She has published three collections of poetry. The most recent, *The Book of Blood* (Cape 2006) was shortlisted for the Costa and Forward Prizes.

— Jim Carruth

Jim Carruth is one of the founders and current chair of St Mungo's Mirrorball, a network of Glasgow-based poets, and is the artistic adviser for StAnza: Scotland's International Poetry Festival. His first collection, *Bovine Pastoral,* came out in 2004 and was followed by five pamphlet collections, most recently *Working the Hill* (Mariscat, 2011) and *Rider at the Crossing* (Happenstance 2012). In 2009 he was awarded a Robert Louis Stevenson Fellowship and was the winner of the James McCash poetry competition. In 2010 he brought out *Grace Notes 1959,* a personal response to four classic and ground breaking jazz albums. In 2013 he was the winner of the The McLellan Poetry Prize.

ACKNOWLEDGEMENTS

Thank you to Creative Scotland for financial support for this project and many others. Thanks and appreciation to John Pelan of the Scottish Civic Trust for early time and encouragement, Ray McKenzie for his invaluable reference, *Public Sculpture of Glasgow,* Mike Brooke for additional photography at short notice, Jean-Xavier Boucherat for getting the ball rolling, Stefanie Lehmann for hard graft, attention to detail and unflappability, and Robbie Guillory for ongoing enthusiasm, support and application. Again, grateful thanks to the poets, already named. Final thanks to David Barbour for doing more than anyone to make this project happen and Andrew Forteath for skill, expertise, stamina and creativity. And not forgetting Margaret McGarry, for bringing me to Glasgow.